A BOOK OF INSPIRATIONAL BIBLE MASTERPIECES

P9-CQQ-199

with text from *The Holy Bible*, authorized King James Version and an Introduction by Boyce M. Bennett, Jr., Th.D.

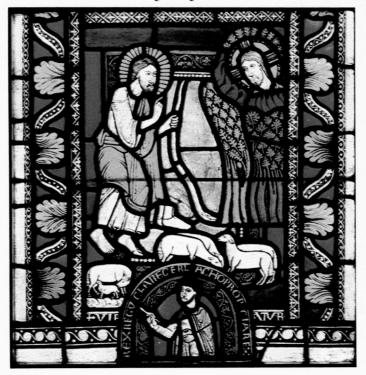

Compiled by Pamela Riddle Designed by Ken Sansone

> Harmony Books New York

Editor's Note:

We have tried to keep to the chronology of the major events in the life of Jesus rather than following the order of the separate Scriptures of the New Testament. For example that is why some verses from St. Luke precede and follow verses from St. Matthew and others.

Title page illustration: Stained glass panel, untitled Gerlachus, Rhenish, twelfth century Above: American engraving, c. 1890

Publisher: Bruce Harris Editor: Pamela Riddle Production: Gene Conner, Murray Schwartz Typography: B.P.E. Graphics, Spring Valley, New York

First published, 1977, in the United States by Harmony Books, a division of Crown Publishers, Incorporated. All Rights Reserved under the International Copyright Union by Harmony Books. No part of this book may be utilized or reproduced in any form or by any means, electronic or mechanical, including photocopying, recording, or by any information storage and retrieval system without permission in writing from the Publisher.

 $H \cdot A \cdot R \cdot M \cdot O \cdot N \cdot Y \quad B \cdot O \cdot O \cdot K \cdot S$

Harmony Books, a division of Crown Publishers, Incorporated One Park Avenue, New York, New York 10016

Published simultaneously in Canada by General Publishing Company Limited. Printed in Japan by Dai Nippon Printing Company, Limited, Tokyo.

> Library of Congress Cataloging in Publication Data Bible. English. Authorized. Selections. 1977. Lift up thine eyes. 1. Bible—Pictures, illustrations, etc. I. Riddle, Pamela, 1946- II. Title. BS391.2.B34 1977 220.5'203 77-10179 ISBN 0-517-53184-4/ISBN 0-517-53120-8 pbk.

INTRODUCTION

90 M de 22 90 M de 290 M de 290 M de 290 M de 290 M de

HE BIBLE is composed of words, not pictures, whereas this book is composed primarily of pictures, not words. The original books of the Bible had no pictures because the ancient Hebrews had been prohibited from making "likenesses" by their Second Commandment. "Thou shalt not make unto thee any graven image, or any

graven image, or any likeness of any thing that is in heaven above, or that is in the earth beneath, or that is in the water under the earth..." (Ex. 20:4). This commandment was necessary for the Hebrews because of the prevalence of idolatry among the people who surrounded them. The temptation was very strong for the People of God to worship these images. And yet, the Bible itself is full of images—verbal images which have proved to be powerful enough to influence the course of the history of the world.

Throughout the centuries, when people have read the Bible, their minds have constructed the images which the words have evoked. Those who were artistically inclined have been moved by an almost irrestible urge to express the images in concrete form. Thus the origins of Biblical art.

But the verbal images of the Bible evoke different impressions from different artists. An artist living in one period and one culture will see things differently from a second artist who lives in another culture and in another period. The variety of styles and art forms found in the pages of this book illustrate this fact quite vividly. Each image is clothed with presuppositions and assumptions about reality that are appropriate for that culture and that period-from the detailed realism and humanity apparent in the work of Michelangelo, to the mysterious spirituality of William Blake and the surrealism of Salvador Dali. The tremendous variety of art forms from the various ages might lead us to believe that our perceptions about the Bible are quite relative and very time-conditioned. And this would be true. We can see it in the nineteenth-century Sunday School approach to Jesus Christ and Christianity exemplified by Bernhard Plockhorst's "Jesus Blessing the Children," or in the contemporary costumes worn by the subjects in Fouquet's "Battle of Jericho," Campin's "Annunciation," or in "The Adoration of the Magi" by Hieronymous Bosch. But it is also true that the images contained in the Bible have a permanence and an absolute nature that makes them stand on their own even without interpretation. They are what they are. We see them differently, depending upon who we are, but they have a kind of timeless quality that is almost impossible to verbalize. They speak to us on levels which are usually not put into words.

What is obvious is that the verbal imagery in the Bible grips the human mind in a way that impells it to express that impact in some tangible form. The expression frequently finds its outlet in artistic creation itself. Thus the works portrayed in this book. But what is more important, it even finds its outlet sometimes in the artistic creation of new lives—lives which have internalized those images and incorporated them into the very fabric of our humanity. This, after all, is what the Bible is really about. It is a book that serves as a fountainhead of creativity, and it proclaims that the ultimate source of that creativity is God Himself.

> –BOYCE M. BENNETT, JR. Th. D. General Theological Seminary New York

GENESIS 1: 1-25

n the beginning God created the heaven and the earth.

2 And the earth was without form, and void; and darkness was upon

the face of the deep. And the Spirit of God moved upon the face of the waters.

3 And God said, Let there be light: and there was light.

4 And God saw the light, that *it was* good: and God divided the light from the darkness.

5 And God called the light Day, and the darkness he called Night. And the evening and the morning were the first day.

6 And God said, Let there be a firmament in the midst of the waters, and let it divide the waters from the waters.

7 And God made the firmament, and divided the waters which *were* under the firmament from the waters which *were* above the firmament: and it was so.

8 And God called the firmament Heaven. And the evening and the morning were the second day.

9 And God said, Let the waters under the heaven be gathered together unto one place, and let the

4

dry land appear: and it was so.

10 And God called the dry *land* Earth; and the gathering together of the waters called he Seas: and God saw that it *was* good.

11 And God said, Let the earth bring forth grass, the herb yielding seed, *and* the fruit tree yielding fruit after his kind, whose seed *is* in itself, upon the earth: and it was so.

12 And the earth brought forth grass, *and* herb yielding seed after his kind, and the tree yielding fruit, whose seed *was* in itself, after his kind: and God saw that it was good.

13 And the evening and the morning were the third day.

14 And God said, Let there be lights in the firmament of the heaven to divide the day from the night; and let them be for signs, and for seasons, and for days, and years:

15 And let them be for lights in the firmament of the heaven to give light upon the earth: and it was so.

16 And God made two great lights; the greater light to rule the day, and the lesser light to rule the night: *he made* the stars also.

17 And God set them in the firmament of the heaven to give light upon the earth.

18 And to rule over the day and

over the night, and to divide the light from the darkness: and God saw that *it was* good.

19 And the evening and the morning were the fourth day.

20 And God said, Let the waters bring forth abundantly the moving creature that hath life, and fowl *that* may fly above the earth in the open firmament of heaven.

21 And God created great whales, and every living creature that moveth, which the waters brought forth abundantly, after their kind, and every winged fowl after his kind: and God saw that *it was* good.

22 And God blessed them, saying, Be fruitful, and multiply, and fill the waters in the seas, and let fowl multiply in the earth.

23 And the evening and the morning were the fifth day.

24 And God said, Let the earth bring forth the living creature after his kind, cattle, and creeping thing, and beast of the earth after his kind: and it was so.

25 And God made the beast of the earth after his kind, and cattle after their kind, and every thing that creepeth upon the earth after his kind: and God saw that *it was* good.

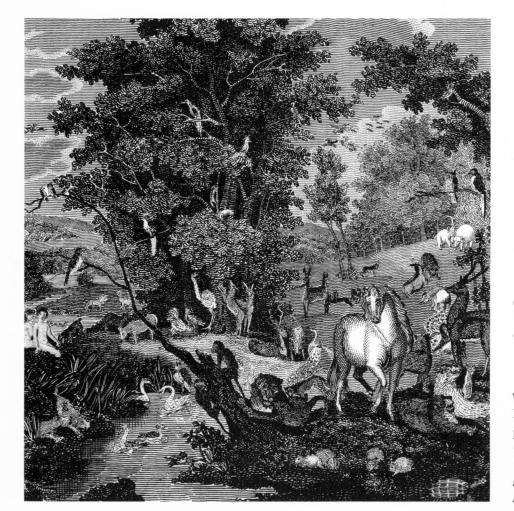

Opposite: *The Ancient of Days* detail watercolor, black ink and gold paint over a relief-etched outline painted in yellow William Blake English, 1757-1827 Left: *The Creation* engraving artist unknown American, c. 1825

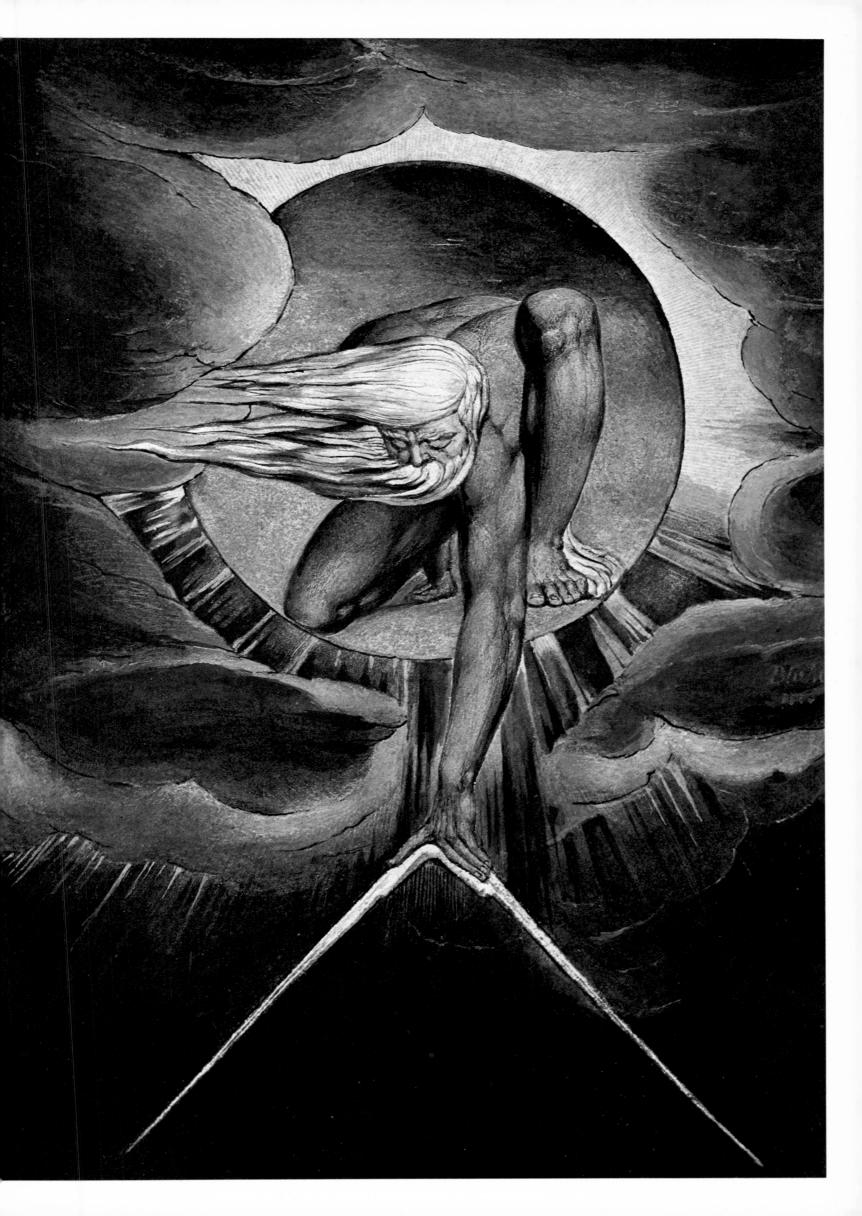

GENESIS 1:26-31

nd God said, Let us make man in our image, after our likeness: and let them have dominion over the fish of the sea, and over the fowl of the air, and over the cattle, and over all the earth, and over every creeping thing that creepeth upon the earth.

27 So God created man in his *own* image, in the image of God created he him; male and female created he them.

28 And God blessed them, and God said unto them, Be fruitful, and multiply, and replenish the earth, and subdue it: and have dominion over the fish of the sea, and over the fowl of

the air, and over every living thing that moveth upon the earth.

29 And God said, Behold, I have given you every herb bearing seed, which *is* upon the face of all the earth, and every tree, in the which *is* the fruit of a tree yielding seed; to you it shall be for meat.

30 And to every beast of the earth, and to every fowl of the air, and to every thing that creepeth upon the earth, wherein *there is* life, *I have given* every green herb for meat: and it was so.

31 And God saw every thing that he had made, and, behold, *it was* very good. And the evening and the morning were the sixth day.

Opposite: God Creating Adam fresco Michelangelo Buonarroti Italian, 1475-1564 Left: Six Days of Creation detail—the Sixth Day woodcut Latin Bible Italian, 1511

6

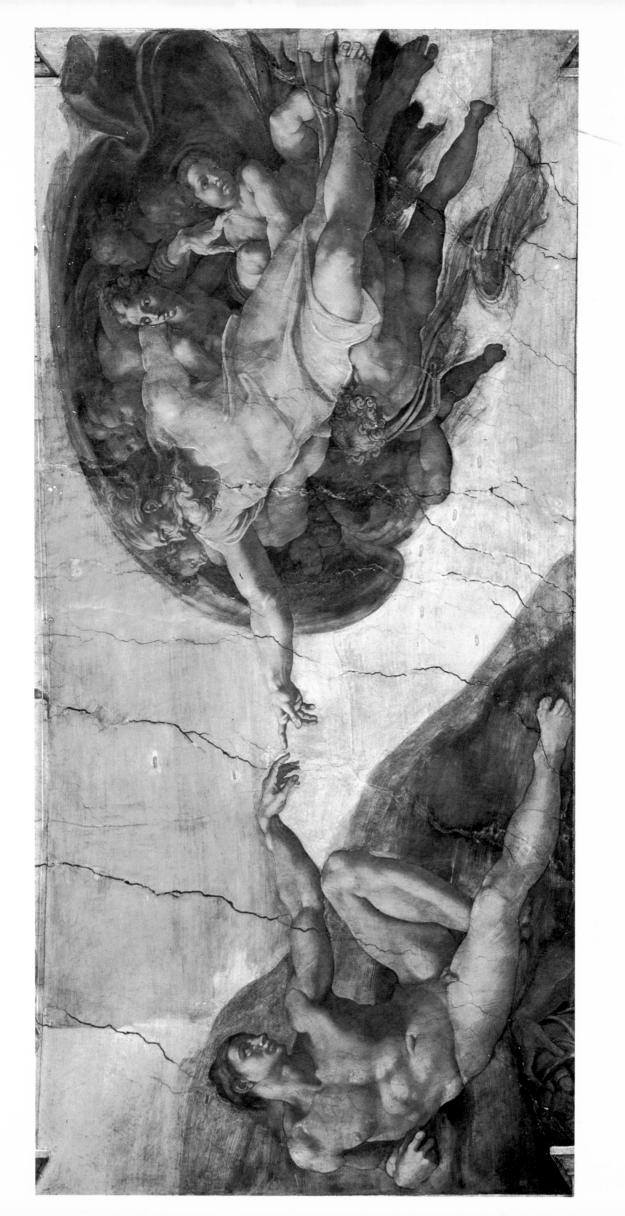

GENESIS 3

ow the serpent was more subtil than any beast of the field which the LORD God had made. And he said unto the woman, Yea, hath God said, Ye shall not eat of every tree of the garden?

2 And the woman said unto the serpent, We may eat of the fruit of the trees of the garden:

3 But of the fruit of the tree which *is* in the midst of the garden, God hath said, Ye shall not eat of it, neither shall ye touch it, lest ye die.

4 And the serpent said unto the woman, Ye shall not surely die:

5 For God doth know that in the day ye eat thereof, then your eyes shall be opened, and ye shall be as gods, knowing good and evil.

6 And when the woman saw that the tree *was* good for food, and that it *was* pleasant to the eyes, and a tree to be desired to make *one* wise, she took of the fruit thereof, and did eat, and gave also unto her husband with her; and he did eat.

7 And the eyes of them both were opened, and they knew that they *were* naked; and they sewed fig leaves together, and made themselves aprons.

8 And they heard the voice of the LORD God walking in the garden in the cool of the day: and Adam and his wife hid themselves from the pres-

ence of the LORD God amongst the trees of the garden.

9 And the LORD God called unto Adam, and said unto him, Where *art* thou?

10 And he said, I heard thy voice in the garden, and I was afraid, because I was naked; and I hid myself.

11 And he said, Who told thee that thou *wast* naked? Hast thou eaten of the tree, whereof I commanded thee that thou shouldest not eat?

12 And the man said, The woman whom thou gavest *to be* with me, she gave me of the tree, and I did eat.

13 And the LORD God said unto the woman, What *is* this *that* thou hast done? And the woman said, The serpent beguiled me, and I did eat.

14 And the LORD God said unto the serpent, Because thou hast done this, thou *art* cursed above all cattle, and above every beast of the field; upon thy belly shalt thou go, and dust shalt thou eat all the days of thy life:

15 And I will put enmity between thee and the woman, and between thy seed and her seed; it shall bruise thy head, and thou shalt bruise his heel.

16 Unto the woman he said, I will greatly multiply thy sorrow and thy conception; in sorrow thou shalt bring forth children; and thy desire *shall be* to thy husband, and he shall rule over thee.

17 And unto Adam he said, Because thou hast hearkened unto the voice of thy wife, and hast eaten of the tree, of which I commanded thee, saying, Thou shalt not eat of it: cursed *is* the ground for thy sake; in sorrow shalt thou eat *of* it all the days of thy life;

18 Thorns also and thistles shall it bring forth to thee; and thou shalt eat the herb of the field;

19 In the sweat of thy face shalt thou eat bread, till thou return unto the ground; for out of it wast thou taken: for dust thou *art*, and unto dust shalt thou return.

20 And Adam called his wife's name Eve; because she was the mother of all living.

21 Unto Adam also and to his wife did the LORD God make coats of skins, and clothed them.

22 And the LORD God said, Behold, the man is become as one of us, to know good and evil: and now, lest he put forth his hand, and take also of the tree of life, and eat, and live for ever:

23 Therefore the LORD God sent him forth from the garden of Eden, to till the ground from whence he was taken.

24 So he drove out the man; and he placed at the east of the garden of Eden Cherubims, and a flaming sword which turned every way, to keep the way of the tree of life.

Explusion from Paradise tempera on panel Giovanni di Paolo Italian, c. 1422-1482

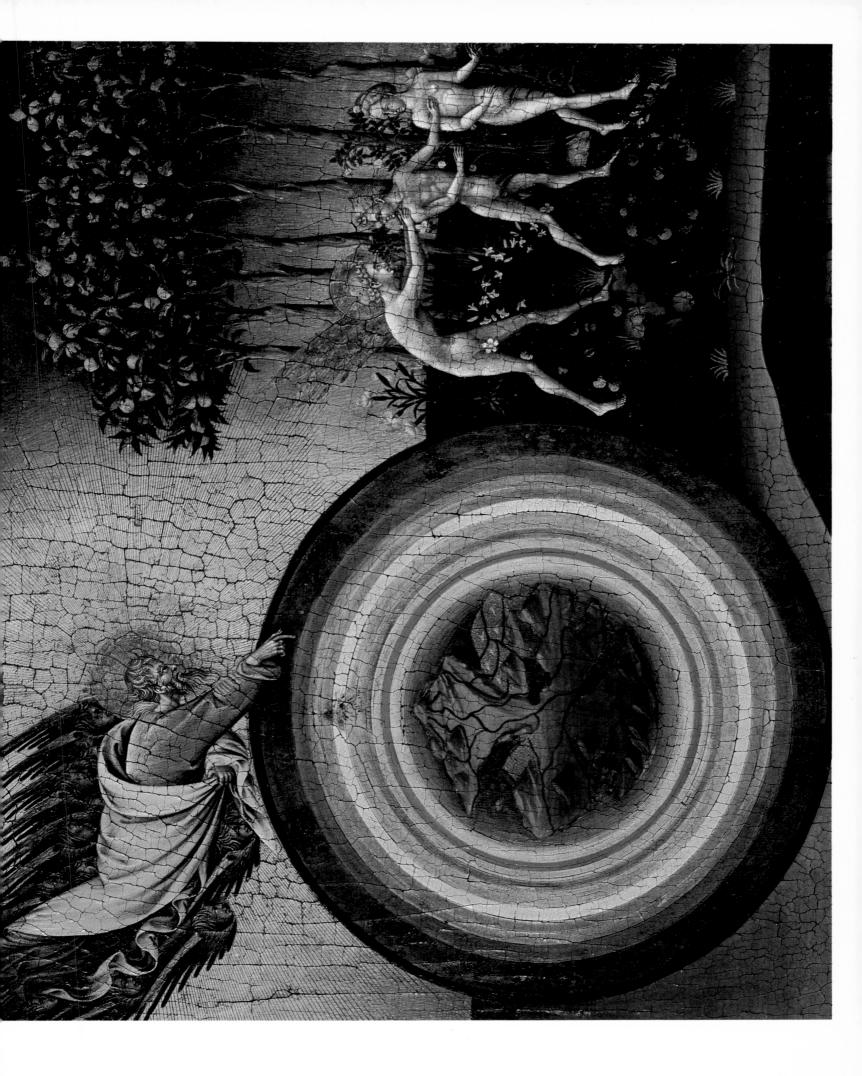

GENESIS 7 AND 8:1-11

CHAPTER 7

nd the Lord said unto Noah, Come thou and all thy house into the ark; for thee have I seen righteous before me in this generation.

2 Of every clean beast thou shalt take to thee by sevens, the male and his female: and of beasts that *are* not clean by two, the male and his female.

3 Of fowls also of the air by sevens, the male and the female; to keep seed alive upon the face of all the earth.

4 For yet seven days, and I will cause it to rain upon the earth forty days and forty nights; and every living substance that I have made will I destroy from off the face of the earth.

5 And Noah did according unto all that the Lord commanded him.

6 And Noah *was* six hundred years old when the flood of waters was upon the earth.

7 And Noah went in, and his sons, and his wife, and his sons' wives with him, into the ark, because of the waters of the flood.

8 Of clean beasts, and of beasts that *are* not clean, and of fowls, and of every thing that creepeth upon the earth,

9 There went in two and two unto Noah into the ark, the male and the female, as God had commanded Noah.

10 And it came to pass after seven days, that the waters of the flood were upon the earth.

11 In the six hundredth year of Noah's life, in the second month, the seventeenth day of the month, the same day were all the fountains of the great deep broken up, and the windows of heaven were opened.

12 And the rain was upon the earth forty days and forty nights.

13 In the selfsame day entered Noah, and Shem, and Ham, and

Japheth, the sons of Noah, and Noah's wife, and the three wives of his sons with them, into the ark;

14 They, and every beast after his kind, and all the cattle after their king, and every creeping thing that creepeth upon the earth after his kind, and every fowl after his kind, every bird of every sort.

15 And they went in unto Noah into the ark, two and two of all flesh, wherein *is* the breath of life.

16 And they that went in, went in male and female of all flesh, as God and commanded him: and the Lord shut him in.

17 And the flood was forty days upon the earth; and the waters increased, and bare up the ark, and it was lift up above the earth.

18 And the waters prevailed, and were increased greatly upon the earth; and the ark went upon the face of the waters.

19 And the waters prevailed exceedingly upon the earth; and all the high hills, that *were* under the whole heaven, were covered.

20 Fifteen cubits upward did the waters prevail; and the mountains were covered.

21 And all flesh died that moved upon the earth, both of fowl, and of cattle, and of beast, and of every creeping thing that creepeth upon the earth, and every man:

22 All in whose nostrils *was* the breath of life, of all that *was* in the dry *land*, died.

23 And every living substance was destroyed which was upon the face of the ground, both man, and cattle, and the creeping things, and the fowl of the heaven; and they were destroyed from the earth: and Noah only remained *alive*, and they that *were* with him in the ark.

24 And the waters prevailed upon the earth an hundred and fifty days.

CHAPTER 8 nd God remembered Noah, and every living thing, and all the cattle that *was* with him in the ark: and God made a wind to pass over

asswaged; 2 The fountains also of the deep and the windows of heaven were stopped, and the rain from heaven was restrained;

the earth, and the waters

3 And the waters returned from off the earth continually: and after the end of the hundred and fifty days the waters were abated.

4 And the ark rested in the seventh month, on the seventeenth day of the month, upon the mountains of Ararat.

5 And the waters decreased continually until the tenth month: in the tenth *month*, on the first *day* of the month, were the tops of the mountains seen.

6 And it came to pass at the end of forty days, that Noah opened the window of the ark which he had made:

7 And he sent forth a raven, which went forth to and fro, until the waters were dried up from off the earth.

8 Also he sent forth a dove from him, to see if the waters were abated from off the face of the ground;

9 But the dove found no rest for the sole of her foot, and she returned unto him into the ark, for the waters *were* on the face of the whole earth: then he put forth his hand, and took her, and pulled her in unto him into the ark.

10 And he stayed yet another seven days; and again he sent forth the dove out of the ark;

11 And the dove came in to him in the evening; and lo, in her mouth *was* an olive leaf pluckt off: so Noah knew that the waters were abated from off the earth.

Opposite: Noah's Ark oil on canvas Edward Hicks American, 1780-1849 Left: Dove engraving artist unknown American, c. 1890

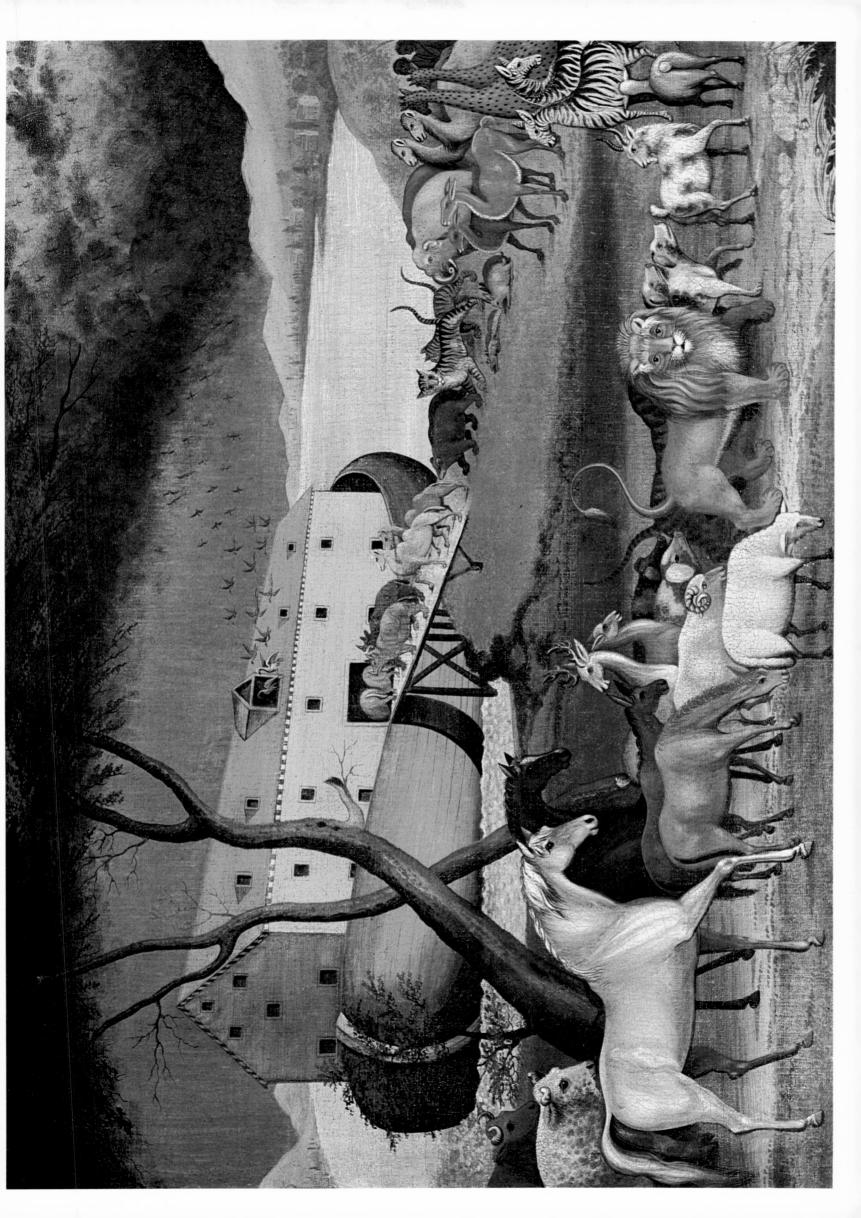

GENESIS 28:1-22

nd Isaac called Jacob, and blessed him, and charged him, and said unto him, Thou shalt not take a wife of the daughters of Canaan.

2 Arise, go to Padanaram, to the house of Bethuel thy mother's father; and take thee a wife from thence of the daughters of Laban thy mother's brother.

3 And God Almighty bless thee, and make thee fruitful, and multiply thee, that thou mayest be a multitude of people;

4 And give thee the blessing of Abraham to thee, and to thy seed with thee; that thou mayest inherit the land wherein thou art a stranger, which God gave unto Abraham.

5 And Isaac sent away Jacob: and he went to Padanaram unto Laban, son of Bethuel the Syrian, the brother of Rebekah, Jacob's and Esau's mother.

6 When Esau saw that Isaac had blessed Jacob, and sent him away to Padanaram, to take him a wife from thence; and that as he blessed him he gave him a charge, saying, Thou shalt not take a wife of the daughters of Canaan;

7 And that Jacob obeyed his father and his mother, and was gone to Padanaram; 8 And Esau seeing that the daughters of Canaan pleased not Isaac his father;

9 Then went Esau unto Ishmael, and took unto the wives which he had Mahalath the daughter of Ishmael Abraham's son, the sister of Nebajoth, to be his wife.

10 And Jacob went out from Beersheba, and went toward Haran.

11 And he lighted upon a certain place, and tarried there all night, because the sun was set; and he took of the stones of that place, and put *them for* his pillows, and lay down in that place to sleep.

12 And he dreamed, and behold a ladder set up on the earth, and the top of it reached to heaven: and behold the angels of God ascending and descending on it.

13 And, behold, the Lord stood above it, and said, I *am* the Lord God of Abraham thy father, and the God of Isaac: the land whereon thou liest to thee will I give it, and to thy seed:

14 And thy seed shall be as the dust of the earth, and thou shalt spread abroad to the west, and to the east, and to the north, and to the south: and in thee and in thy seed shall all the families of the earth be blessed.

15 And, behold, I *am* with thee, and will keep thee in all *places* whither thou goest, and will bring thee again

into this land; for I will not leave thee, until I have done *that* which I have spoken to thee of.

16 And Jacob awaked out of his sleep, and he said, Surely the Lord is in this place; and I knew *it* not.

17 And he was afraid, and said, How dreadful *is* this place! this *is* none other but the house of God, and this *is* the gate of heaven.

18 And Jacob rose up early in the morning, and took the stone that he had put *for* his pillows, and set it up *for* a pillar, and poured oil upon the top of it.

19 And he called the name of that place Bethel: but the name of that city *was called* Luz at the first.

20 And Jacob vowed a vow, saying, If God will be with me, and will keep me in this way that I go, and will give me bread to eat, and raiment to put on,

21 So that I come again to my father's house in peace; then shall the Lord be my God:

22 And this stone, which I have set *for* a pillar, shall be God's house: and of all that thou shalt give me I will surely give the tenth unto thee.

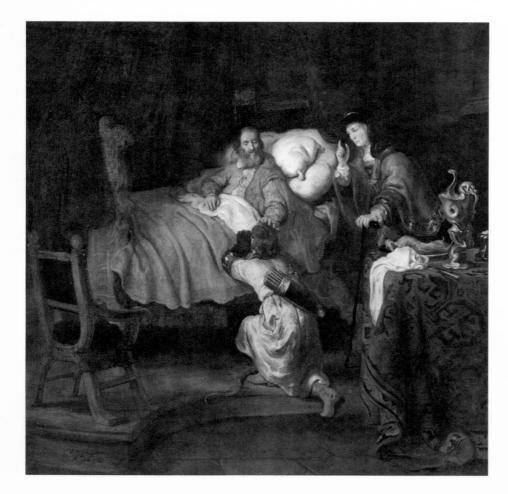

Opposite: Jacob's Dream oil on canvas Domenico Feti Italian, 1589-1624 Left: Isaac Blessing Jacob detail oil on canvas Gerbrandt van den Eeckhout, German, 1621-1674

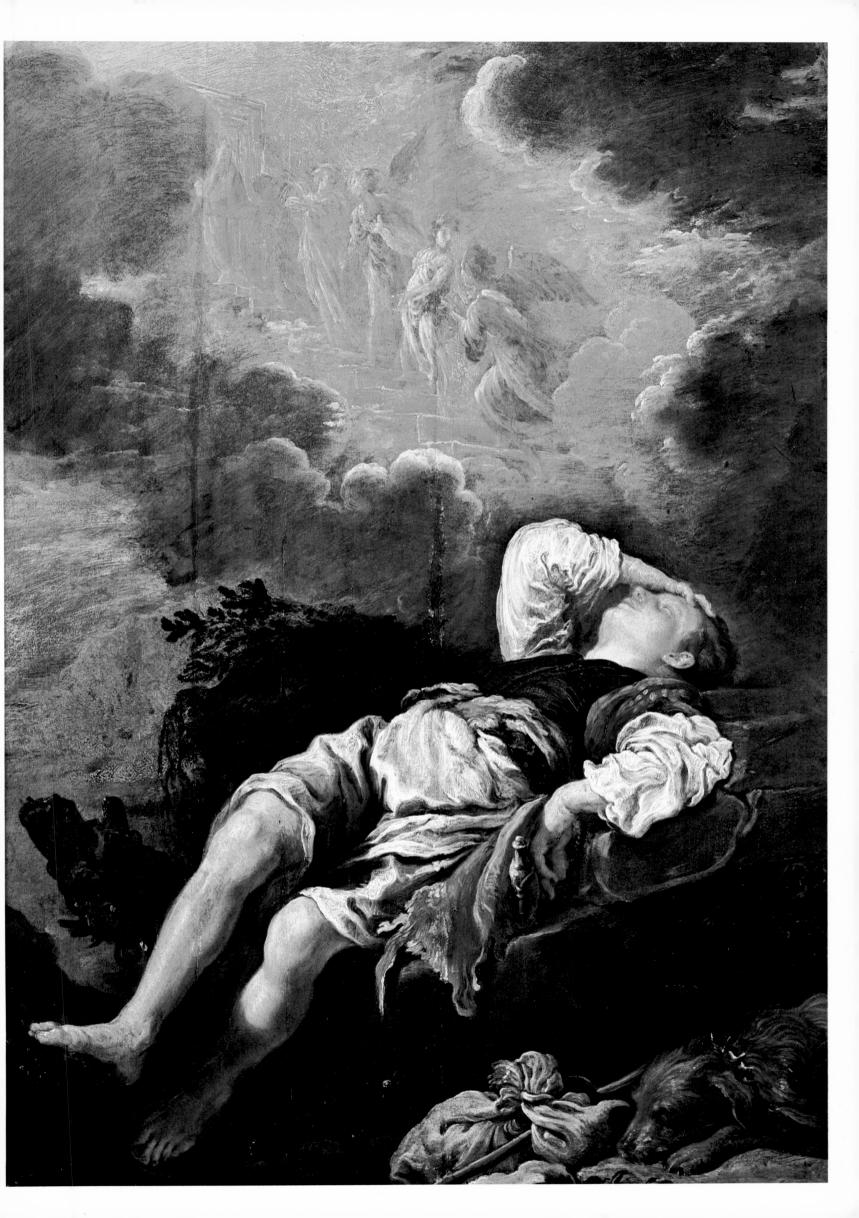

GENESIS 37

nd Jacob dwelt in the land wherein his father was a stranger, in the land of Canaan. 2 These *are* the genera-

tions of Jacob. Joseph, being seventeen years old, was feeding the flock with his brethren; and the lad was with the sons of Bilhah, and with the sons of Zilpah, his father's wives: and Joseph brought unto his father their evil report.

3 Now Israel loved Joseph more than all his children, because he *was* the son of his old age: and he made him a coat of *many* colours.

4 And when his brethren saw that their father loved him more than all his brethren, they hated him, and could not speak peaceably unto him.

5 And Joseph dreamed a dream, and he told *it* his brethren: and they hated him yet the more.

6 And he said unto them, Hear, I pray you, this dream which I have dreamed:

7 For, behold, we *were* binding sheaves in the field, and, lo, my sheaf arose, and also stood upright; and, behold, your sheaves stood round about, and made obeisance to my sheaf.

8 And his brethren said to him, Shalt thou indeed reign over us? or shalt thou indeed have dominion over us? And they hated him yet the more for his dreams, and for his words.

9 And he dreamed yet another dream, and told it his brethren, and said, Behold, I have dreamed a dream more; and, behold, the sun and the moon and the eleven stars made obeisance to me.

10 And he told *it* to his father, and to his brethren: and his father rebuked him, and said unto him, What *is* this dream that thou hast dreamed? Shall I and thy mother and thy brethren indeed come to bow down ourselves to thee to the earth?

11 And his brethren envied him; but his father observed the saying.

12 And his brethren went to feed

their father's flock in Shechem.

13 And Israel said unto Joseph, Do not thy brethren feed *the flock* in Shechem? come, and I will send thee unto them. And he said to him, Here *am I*.

14 And he said to him, Go, I pray thee, see whether it be well with thy brethren, and well with the flocks; and bring me word again. So he sent him out of the vale of Hebron, and he came to Shechem.

15 And a certain man found him, and, behold, *he was* wandering in the field: and the man asked him, saying, What seekest thou?

16 And he said, I seek my brethren: tell me, I pray thee, where they feed *their flocks*.

17 And the man said, They are departed hence; for I heard them say, Let us go to Dothan. And Joseph went after his brethren, and found them in Dothan.

18 And when they saw him afar off, even before he came near unto them, they conspired against him to slay him.

19 And they said one to another, Behold, this dreamer cometh.

20 Come now therefore, and let us slay him, and cast him into some pit, and we will say, Some evil beast hath devoured him: and we shall see what will become of his dreams.

21 And Reuben heard *it*, and he delivered him out of their hands; and said, Let us not kill him.

22 And Reuben said unto them, Shed no blood, *but* cast him into this pit that *is* in the wilderness, and lay no hand upon him; that he might rid him out of their hands, to deliver him to his father again.

23 And it came to pass, when Joseph was come unto his brethren, that they stript Joseph out of his coat, *his* coat of *many* colours that *was* on him;

24 And they took him, and cast him into a pit: and the pit *was* empty, *there was* no water in it.

25 And they sat down to eat bread:

and they lifted up their eyes and looked, and, behold, a company of Ishmeelites came from Gilead with their camels bearing spicery and balm and myrrh, going to carry *it* down to Egypt.

26 And Judah said unto his brethren, What profit *is it* if we slay our brother, and conceal his blood?

27 Come, and let us sell him to the Ishmeelites, and let not our hand be upon him, for he *is* our brother *and* our flesh. And his brethren were content.

28 Then there passed by Midianites merchantmen; and they drew and lifted up Joseph out of the pit, and sold Joseph to the Ishmeelites for twenty *pieces* of silver: and they brought Joseph to Egypt.

29 And Reuben returned unto the pit; and, behold, Joseph *was* not in the pit; and he rent his clothes.

30 And he returned unto his brethren, and said, The child *is* not; and I, whither shall I go?

31 And they took Joseph's coat, and killed a kid of the goats, and dipped the coat in the blood;

32 And they sent the coat of *many* colours, and they brought *it* to their father; and said, This have we found: know now whether it *be* thy son's coat or no.

33 And he knew it, and said, *It is* my son's coat; an evil beast hath devoured him; Joseph is without doubt rent in pieces.

34 And Jacob rent his clothes, and put sackcloth upon his loins, and mourned for his son many days.

35 And all his sons and all his daughters rose up to comfort him; but he refused to be comforted; and he said, For I will go down into the grave unto my son mourning. Thus his father wept for him.

36 And the Midianites sold him to Egypt unto Potiphar, an officer of Pharaoh's, *and* captain of the guard.

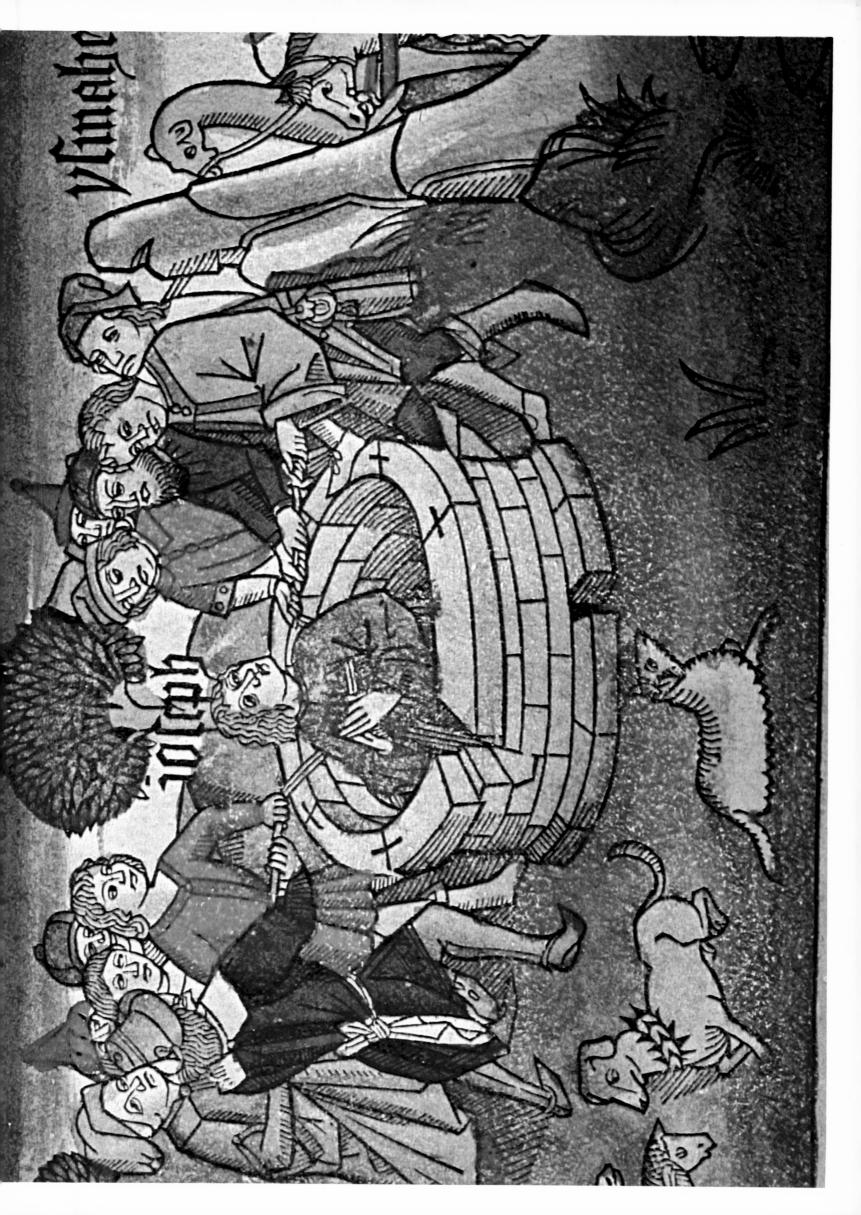

EXODUS 20

nd God spake all these words, saying,

2 I *am* the Lord thy God, which have brought thee out of the land of Egypt, out of the house of bond-

3 Thou shalt have no other gods before me.

4 Thou shalt not make unto thee any graven image, or any likeness of any thing that is in heaven above, or that is in the earth beneath, or that is in the water under the earth.

5 Thou shalt not bow down thyself to them, nor serve them: for I the Lord thy God *am* a jealous God, visiting the iniquity of the fathers upon the children unto the third and fourth *generation* of them that hate me;

6 And shewing mercy unto thousands of them that love me, and keep my commandments.

7 Thou shalt not take the name of the Lord thy God in vain; for the Lord will not hold him guiltless that taketh his name in vain.

8 Remember the sabbath day, to keep it holy.

9 Six days shalt thou labour, and do all thy work:

10 But the seventh day is the

sabbath of the Lord thy God: *in it* thou shalt not do any work, thou, nor thy son, nor thy daughter, thy manservant, nor thy maidservant, nor thy cattle, nor thy stranger that *is* within thy gates:

11 For *in* six days the Lord made heaven and earth, the sea, and all that in them *is*, and rested the seventh day: wherefore the Lord blessed the sabbath day, and hallowed it.

12 Honour thy father and thy mother: that thy days may be long upon the land which the Lord thy God giveth thee.

13 Thou shalt not kill.

14 Thou shalt not commit adultery.

15 Thou shalt not steal.

16 Thou shalt not bear false witness against thy neighbour.

17 Thou shalt not covet thy neighbour's house, thou shalt not covet thy neighbour's wife, nor his manservant, nor his maidservant, nor his ox, nor his ass, nor any thing that *is* thy neighbour's.

18 And all the people saw the thunderings, and the lightnings, and the noise of the trumpet, and the mountain smoking: and when the people saw *it*, they removed, and stood afar off.

19 And they said unto Moses, Speak thou with us, and we will hear: but let not God speak with us, lest we die.

20 And Moses said unto the people, Fear not: for God is come to prove you, and that his fear may be before your faces, that ye sin not.

21 And the people stood afar off, and Moses drew near unto the thick darkness where God *was*.

22 And the Lord said unto Moses, Thus thou shalt say unto the children of Israel, Ye have seen that I have talked with you from heaven.

23 Ye shall not make with me gods of silver, neither shall ye make unto you gods of gold.

24 An altar of earth thou shalt make unto me, and shalt sacrifice thereon thy burnt offerings, and thy peace offerings, thy sheep, and thine oxen: in all places where I record my name I will come unto thee, and I will bless thee.

25 And if thou wilt make me an altar of stone, thou shalt not build it of hewn stone: for if thou lift up thy tool upon it, thou hast polluted it.

26 Neither shalt thou go up by steps unto mine altar, that thy nakedness be not discovered thereon.

Opposite: *Moses* marble sculpture Michelangelo Buonarroti Italian, 1475-1564 Left: *The Ten Commandments* engraving Paul Gustave Doré French, 1833-1883

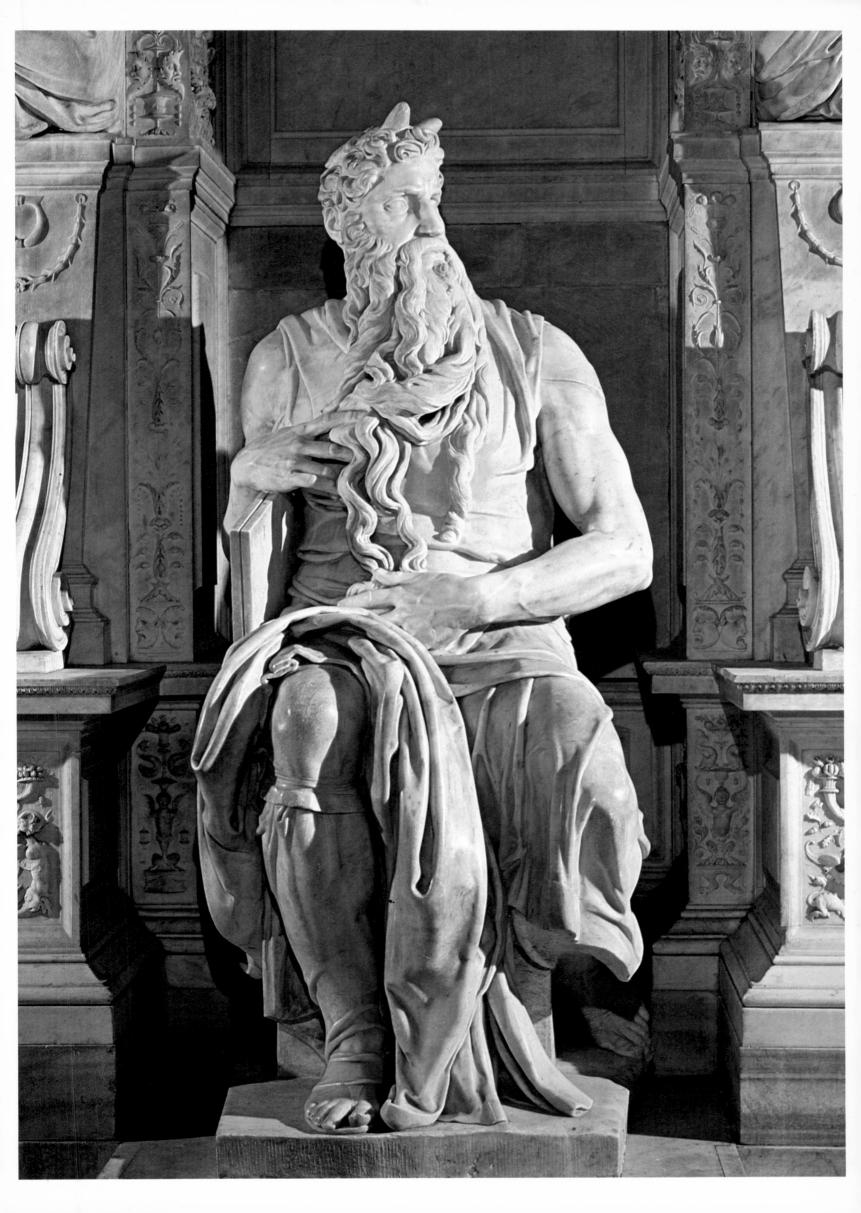

JOSHUA 6:1-20

ow Jericho was straitly shut up because of the children of Israel: none went out, and none came in.

2 And the Lord said unto Joshua, See, I have given into thine hand Jericho, and the king thereof, and the mighty men of valour.

3 And ye shall compass the city, all *ye* men of war, *and* go round about the city once. Thus shalt thou do six days.

4 And seven priests shall bear before the ark seven trumpets of rams' horns: and the seventh day ye shall compass the city seven times, and the priests shall blow with the trumpets.

5 And it shall come to pass, that when they make a long *blast* with the ram's horn, *and* when ye hear the sound of the trumpet, all the people shall shout with a great shout; and the wall of the city shall fall down flat, and the people shall ascend up every man straight before him.

6 And Joshua the son of Nun called the priests, and said unto them, Take up the ark of the covenant, and let seven priests bear seven trumpets of rams' horns before the ark of the Lord.

7 And he said unto the people, Pass on, and compass the city, and let him that is armed pass on before the ark of the Lord.

8 And it came to pass, when Joshua

had spoken unto the people, that the seven priests bearing the seven trumpets of rams' horns passed on before the Lord, and blew with the trumpets: and the ark of the covenant of the Lord followed them.

9 And the armed men went before the priests that blew with the trumpets, and the rereward came after the ark, *the priests* going on, and blowing with the trumpets.

10 And Joshua had commanded the people, saying, Ye shall not shout, nor make any noise with your voice, neither shall *any* word proceed out of your mouth, until the day I bid you shout; then shall ye shout.

11 So the ark of the Lord compassed the city, going about *it* once: and they came into the camp, and lodged in the camp.

12 And Joshua rose early in the morning, and the priests took up the ark of the Lord.

13 And seven priests bearing seven trumpets of rams' horns before the ark of the Lord went on continually, and blew with the trumpets: and the armed men went before them; but the rereward came after the ark of the Lord, *the priests* going on, and blowing with the trumpets.

14 And the second day they compassed the city once, and returned into the camp: so they did six days.

15 And it came to pass on the

seventh day, that they rose early about the dawning of the day, and compassed the city after the same manner seven times: only on that day they compassed the city seven times.

16 And it came to pass that the seventh time, when the priests blew with the trumpets, Joshua said unto the people, Shout; for the Lord hath given you the city.

17 And the city shall be accursed, even *it*, and all that *are* therein, to the Lord: only Rahab the harlot shall live, she and all that *are* with her in the house, because she hid the messengers that we sent.

18 And ye, in any wise keep *yourselves* from the accursed thing, lest ye make *yourselves* accursed, when ye take of the accursed thing, and make the camp of Israel a curse, and trouble it.

19 But all the silver, and gold, and vessels of brass and iron, *are* consecrated unto the Lord: they shall come into the treasury of the Lord.

20 So the people shouted when *the priests* blew with the trumpets: and it came to pass, when the people heard the sound of the trumpet, and the people shouted with a great shout, that the wall fell down flat, so that the people went up into the city, every man straight before him, and they took the city.

The Fall of Jericho miniature book illustration Jean Fouquet French, c. 1420-1481

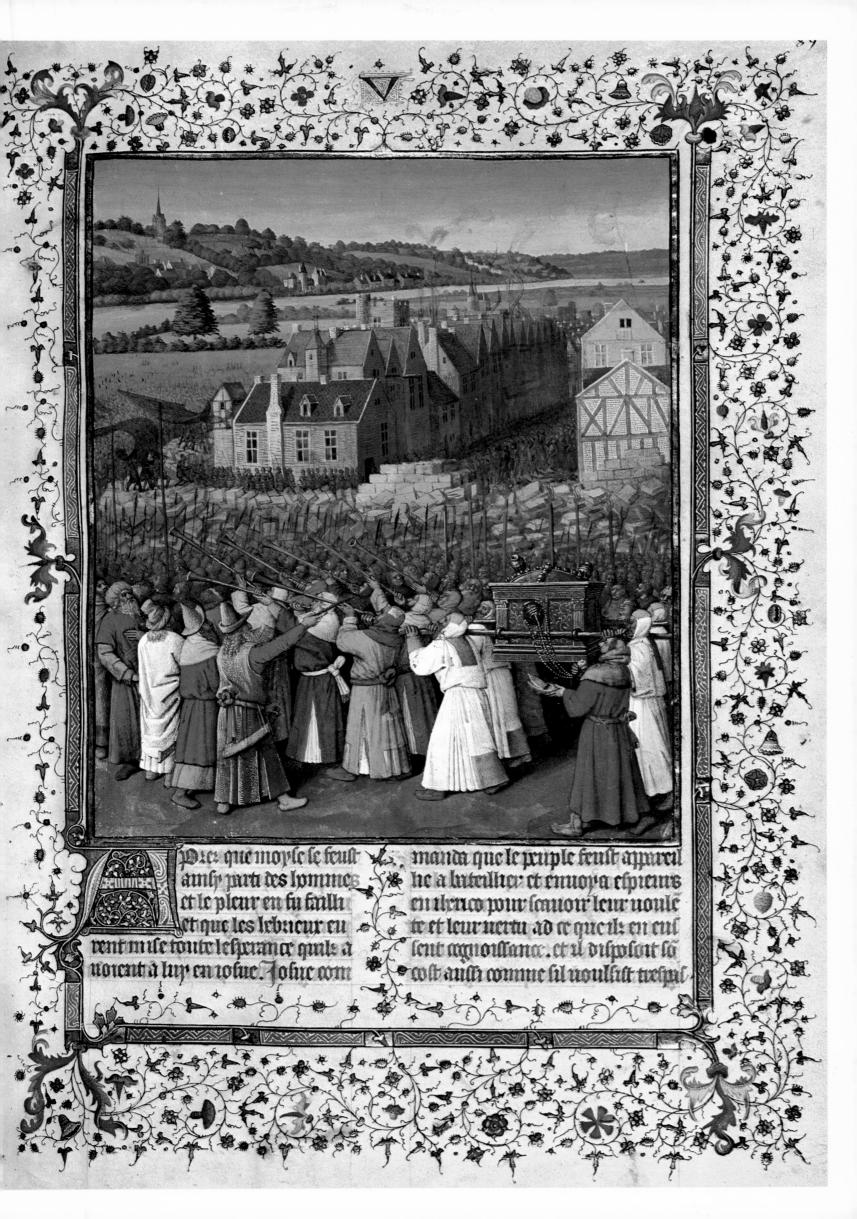

RUTH 3:1-14 AND 4:13-22

Boaz of our kindred, with whose maidens thou wast? Behold, he winnoweth barley to night in the threshingfloor.

3 Wash thyself therefore, and anoint thee, and put thy raiment upon thee, and get thee down to the floor: *but* make not thyself known unto the man, until he shall have done eating and drinking.

4 And it shall be, when he lieth down, that thou shalt mark the place where he shall lie, and thou shalt go in, and uncover his feet, and lay thee down; and he will tell thee what thou shalt do.

5 And she said unto her, All that thou sayest unto me I will do.

6 And she went down unto the floor, and did according to all that her mother in law bade her.

7 And when Boaz had eaten and drunk, and his heart was merry, he went to lie down at the end of the heap of corn: and she came softly, and uncovered his feet, and laid her down.

8 And it came to pass at midnight, that the man was afraid, and turned

himself: and, behold, a woman lay at his feet.

9 And he said, Who *art* thou? And she answered, I *am* Ruth thine handmaid: spread therefore thy skirt over thine handmaid; for thou *art* a near kinsman.

10 And he said, Blessed *be* thou of the Lord, my daughter: *for* thou hast shewed more kindness in the latter end than at the beginning, inasmuch as thou followedst not young men, whether poor or rich.

11 And now, my daughter, fear not; I will do to thee all that thou requirest: for all the city of my people doth know that thou *art* a virtuous woman.

12 And now it is true that I *am thy* near kinsman: howbeit there is a kinsman nearer than I.

13 Tarry this night, and it shall be in the morning, *that* if he will perform unto thee the part of a kinsman, well; let him do the kinsman's part: but if he will not do the part of a kinsman to thee, then will I do the part of a kinsman to thee, *as* the Lord liveth: lie down until the morning.

14 And she lay at his feet until the morning: and she rose up before one could know another. And he said, Let it not be known that a woman came into the floor. CHAPTER 4

o Boaz took Ruth, and she was his wife: and when he went in unto her, the Lord gave her conception, and she bare a son.

14 And the women said unto Naomi, Blessed *be* the Lord, which hath not left thee this day without a kinsman, that his name may be famous in Israel.

15 And he shall be unto thee a restorer *of thy* life, and a nourisher of thine old age: for thy daughter in law, which loveth thee, which is better to thee than seven sons, hath born him.

16 And Naomi took the child, and laid it in her bosom, and became nurse unto it.

17 And the women her neighbours gave it a name, saying, There is a son born to Naomi; and they called his name Obed: he *is* the father of Jesse, the father of David.

18 Now these *are* the generations of Pharez: Pharez begat Hezron,

19 And Hezron begat Ram, and Ram begat Amminadab,

20 And Amminadab begat Nahshon, and Nahshon begat Salmon,

21 And Salmon begat Boaz, and Boaz begat Obed,

22 And Obed begat Jesse, and Jesse begat David.

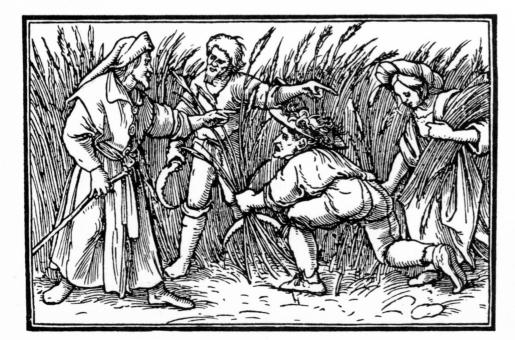

Opposite: *Ruth and Boaz* illuminated manuscript page Lambeth Bible English, sixteenth century Left: *And Boaz said, Whose damsel is this?* engraving Hans Holbein, the Younger German, 1497-1543

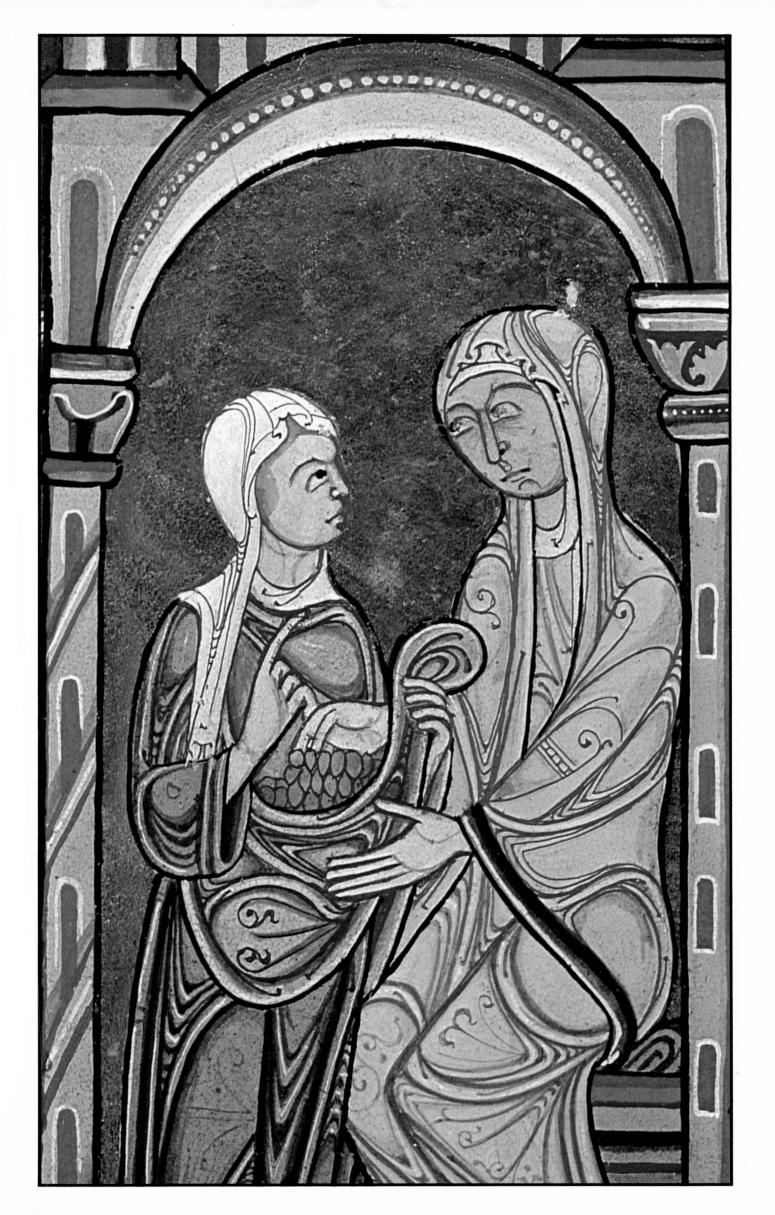

I KINGS 3:16-28

hen came there two women, *that were* harlots, unto the king, and stood before him. 17 And the one wom-

an said, O my lord, I

and this woman dwell in one house; and I was delivered of a child with her in the house.

18 And it came to pass the third day after that I was delivered, that this woman was delivered also: and we *were* together; *there was* no stranger with us in the house, save we two in the house.

19 And this woman's child died in the night; because she overlaid it.

20 And she arose at midnight, and took my son from beside me, while thine handmaid slept, and laid it in her bosom, and laid her dead child in my bosom.

21 And when I rose in the morning to give my child suck, behold, it was dead: but when I had considered it in the morning, behold, it was not my son, which I did bear.

22 And the other woman said, Nay; but the living *is* my son, and the dead *is* thy son. And this said, No; but the dead *is* thy son, and the living *is* my son. Thus they spake before the king.

23 Then said the king, The one saith, This *is* my son that liveth, and thy son *is* the dead: and the other saith, Nay; but thy son *is* the dead, and my son *is* the living.

24 And the king said, Bring me a sword. And they brought a sword before the king.

25 And the king said, Divide the living child in two, and give half to the one, and half to the other.

26 Then spake the woman whose the living child *was* unto the king, for her bowels yearned upon her son, and she said, O my lord, give her the living child, and in no wise slay it. But the other said, Let it be neither mine nor thine, *but* divide *it*.

27 Then the king answered and said, Give her the living child, and in no wise slay it: she *is* the mother thereof.

28 And all Israel heard of the judgment which the king had judged; and they feared the king: for they saw that the wisdom of God *was* in him, to do judgment.

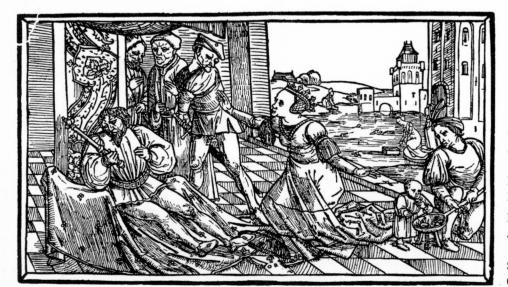

Opposite: Judgment of Solomon oil on canvas Peter Paul Rubens Flemish, 1577-1640 Left: Judgment of Solomon

engraving Steffen Arndes Lübeck, Lübeck Bible German, c. 1500

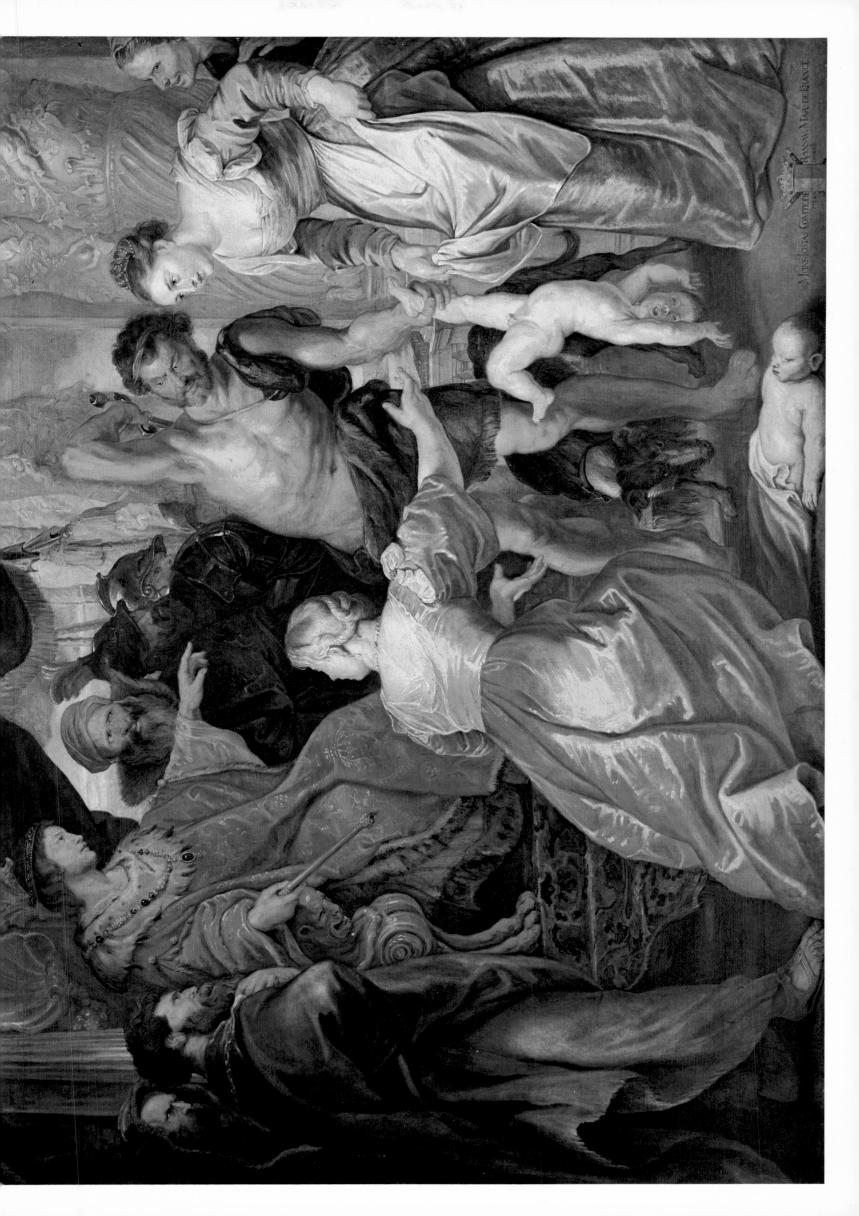

II KINGS 2

nd it came to pass, when the Lord would take up Elijah into heaven by a whirlwind, that Elijah went with Elisha from Gilgal. 2 And Elijah said unto Elisha, Tarry here, I pray thee; for the LORD hath sent me to Bethel. And Elisha said *unto him, As* the LORD liveth, and *as* thy soul liveth, I will not leave thee. So they went down to Bethel.

3 And the sons of the prophets that were at Bethel came forth to Elisha, and said unto him, Knowest thou that the LORD will take away thy master from thy head to day? And he said, Yea, I know *it;* hold ye your peace.

4 And Elijah said unto him, Elisha, tarry here, I pray thee; for the LORD liveth, and *as* thy soul liveth, I will not leave thee. So they came to Jericho.

5 And the sons of the prophets that were at Jericho came to Elisha, and said unto him, Knowest thou that the lord will take away thy master from thy head to day? And he answered, Yea, I know *it;* hold ye your peace.

6 And Elijah said unto him, Tarry, I pray thee, here; for the LORD hath sent me to Jordan. And he said, *As* the LORD liveth, and *as* thy soul liveth, I will not leave thee. And they two went on.

7 And fifty men of the sons of the prophets went, and stood to view afar off: and they two stood by Jordan.

8 And Elijah took his mantle, and wrapped *it* together, and smote the waters, and they were divided hither and thither, so that they two went over on dry ground.

9 And it came to pass, when they

were gone over, that Elijah said unto Elisha, Ask what I shall do for thee, before I be taken away from thee. And Elisha said, I pray thee, let a double portion of thy spirit be upon me.

10 And he said, Thou hast asked a hard thing: *nevertheless*, if thou see me *when I am* taken from thee, it shall be so unto thee; but if not, it shall not be so.

11 And it came to pass, as they still went on, and talked, that, behold, *there appeared* a chariot of fire, and horses of fire, and parted them both asunder; and Elijah went up by a whirlwind into heaven.

12 And Elisha saw *it*, and he cried, My father, my father, the chariot of Israel, and the horsemen thereof. And he saw him no more: and he took hold of his own clothes, and rent them in two pieces.

13 He took up also the mantle of Elijah that fell from him, and went back, and stood by the bank of Jordan;

14 And he took the mantle of Elijah that fell from him, and smote the waters, and said, Where *is* the LORD God of Elijah? and when he also had smitten the waters, they parted hither and thither: and Elisha went over.

15 And when the sons of the prophets which *were* to view at Jericho saw him, they said, The spirit of Elijah doth rest on Elisha. And they came to meet him, and bowed themselves to the ground before him.

16 And they said unto him, Behold now, there be with thy servants fifty strong men; let them go, we pray thee, and seek thy master: lest peradventure the Spirit of the LORD hath taken him up, and cast him upon some mountain, or into some valley. And he said, Ye shall not send.

17 And when they urged him till he was ashamed, he said, Send. They sent therefore fifty men; and they sought three days, but found him not.

18 And when they came again to him, (for he tarried at Jericho,) he said unto them, Did I not say unto you, Go not?

19 And the men of the city said unto Elisha, Behold, I pray thee, the situation of this city *is* pleasant, as my lord seeth: but the water *is* naught, and the ground barren.

20 And he said, Bring me a new cruse, and put salt therein. And they brought *it* to him.

21 And he went forth unto the spring of the waters, and cast the salt in there, and said, Thus saith the LORD, I have healed these waters; there shall not be from thence any more death or barren *land*.

22 So the waters were healed unto this day, according to the saying of Elisha which he spake.

23 And he went up from thence unto Bethel: and as he was going up by the way, there came forth little children out of the city, and mocked him, and said unto him, Go up, thou bald head; go up thou bald head.

24 And he turned back, and looked on them, and cursed them in the name of the LORD. And there came forth two she bears out of the wood, and tare forty and two children of them.

25 And he went from thence to mount Carmel, and from thence he returned to Samaria.

Elijah Taken Up in a Chariot of Fire detail oil on canvas Giovanni Battista Piazetta Italian, 1682-1754

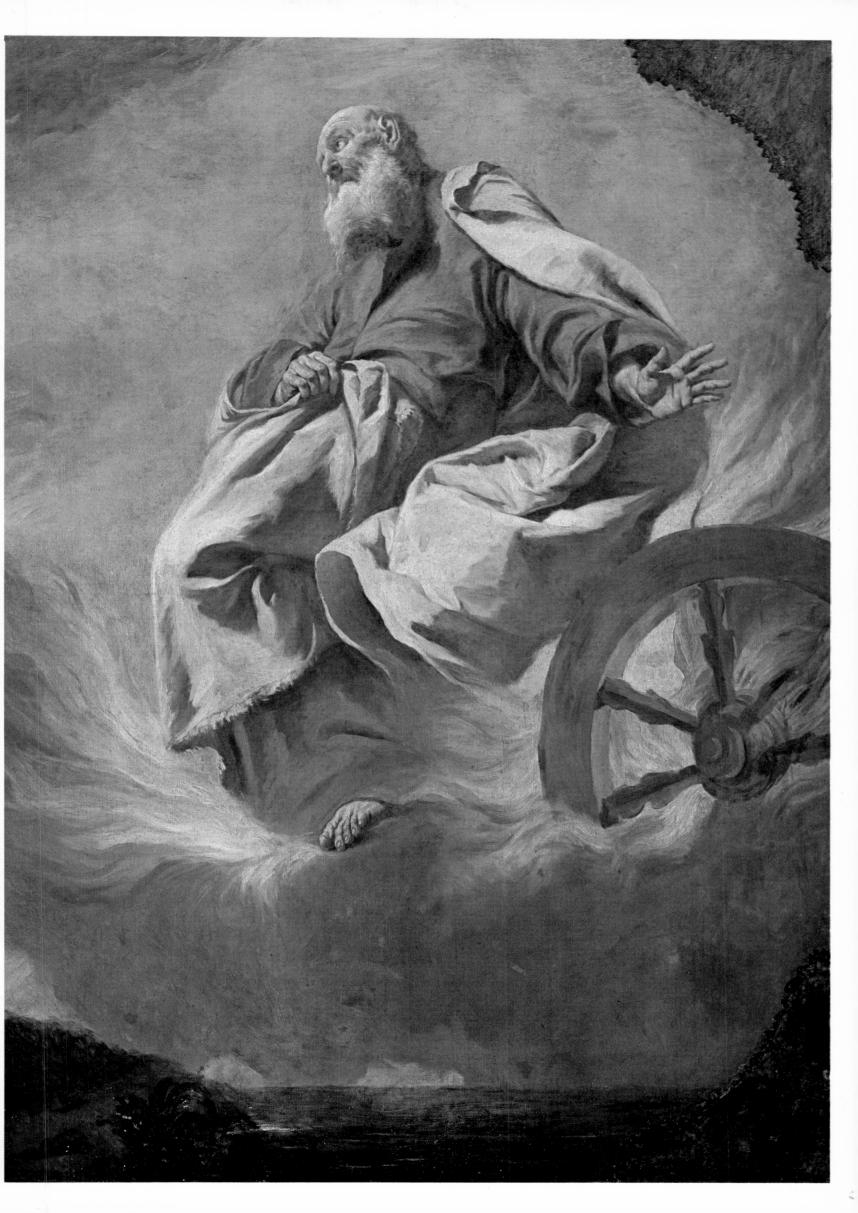

PSALMS 23, 100 AND 123

PSALM 23 The Lord *is* my shepherd; I shall not want. 2 He maketh me to lie down in green pastures: he leadeth me beside

the still waters. 3 He restoreth my soul: he leadeth me in the paths of righteousness for his name's sake.

4 Yea, though I walk through the valley of the shadow of death, I will fear no evil: for thou *art* with me; thy rod and thy staff they comfort me.

5 Thou preparest a table before me in the presence of mine enemies: thou anointest my head with oil; my cup runneth over.

6 Surely goodness and mercy shall follow me all the days of my life: and I will dwell in the house of the Lord for ever.

PSALM 100

ake a joyful noise unto the Lord, all ye lands. 2 Serve the Lord with gladness: come before his

presence with singing.

3 Know ye that the Lord he *is* God: *it is* he *that* hath made us, and not we ourselves; *we are* his people, and the sheep of his pasture.

4 Enter into his gates with thanksgiving, *and* into his courts with praise: be thankful unto him, *and* bless his name.

5 For the Lord *is* good; his mercy *is* everlasting; and his truth *endureth* to all generations.

PSALM 123

 nto thee lift I up mine eyes, O thou that dwellest in the heavens.

2 Behold, as the eyes of servants *look* unto the hand of their mas-

ters, *and* as the eyes of a maiden unto the hand of her mistress; so our eyes *wait* upon the Lord our God, until that he have mercy upon us.

3 Have mercy upon us, O Lord, have mercy upon us: for we are exceedingly filled with contempt.

4 Our soul is exceedingly filled with the scorning of those that are at ease, *and* with the contempt of the proud.

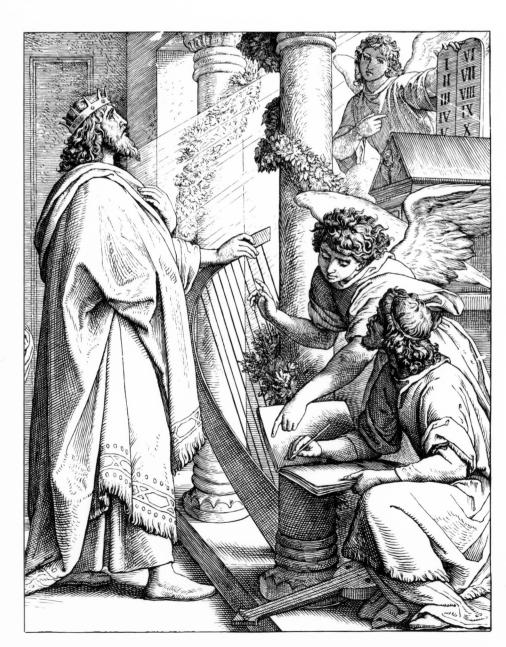

Opposite: David gilt and tempera on wood panel Lorenzo Monaco Italian, c. 1370-1425 Left: David the Psalmist detail engraving F. Obermann German, nineteenth century

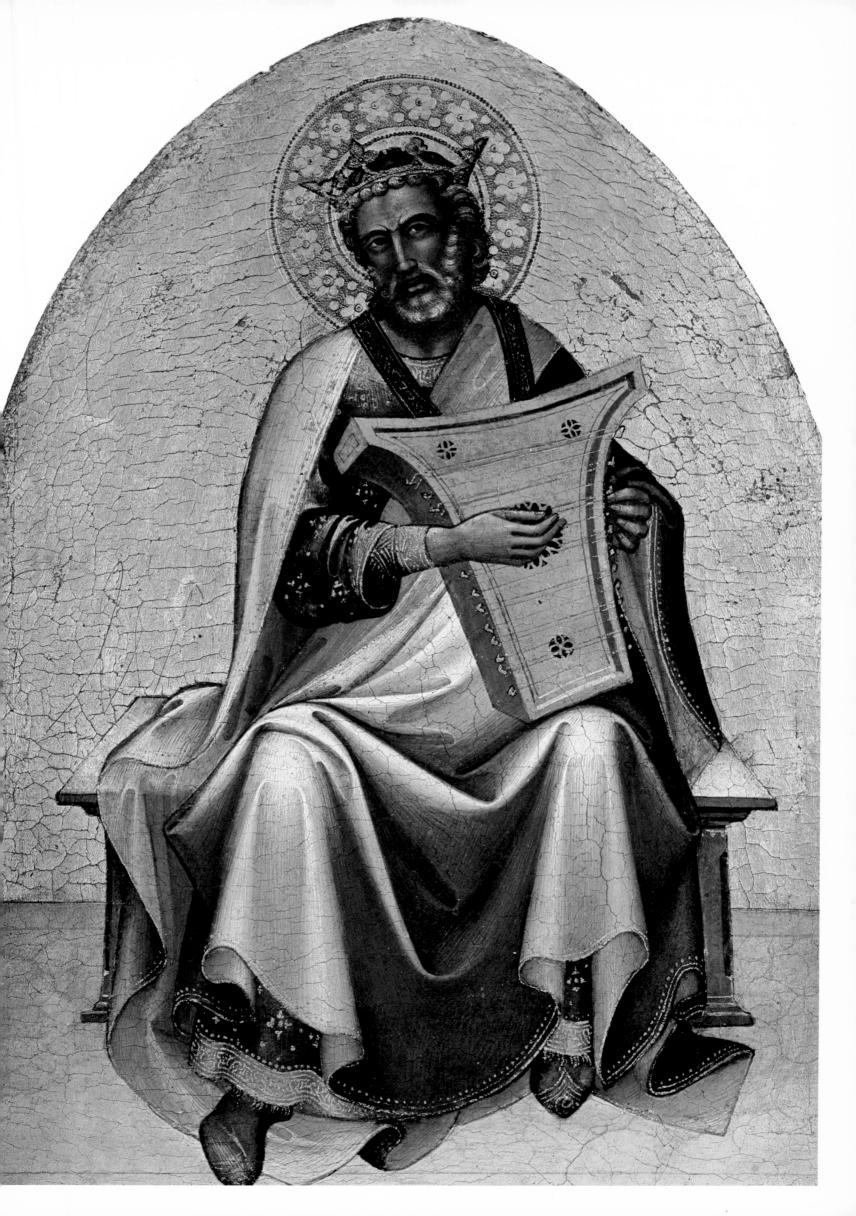

DANIEL 6:1-28

t pleased Darius to set over the kingdom an hundred and twenty princes, which should be over the whole kingdom;

2 And over these three presidents; of whom Daniel *was* first: that the princes might give accounts unto them, and the king should have no damage.

3 Then this Daniel was preferred above the presidents and princes, because an excellent spirit *was* in him; and the king thought to set him over the whole realm.

4 Then the presidents and princes sought to find occasion against Daniel concerning the kingdom; but they could find none occasion nor fault; forasmuch as he *was* faithful, neither was there any error or fault found in him.

5 Then said these men, We shall not find any occasion against this Daniel, except we find *it* against him concerning the law of his God.

6 Then these presidents and princes assembled together to the king, and said thus unto him, King Darius, live for ever.

7 All the presidents of the kingdom, the governors, and the princes, the counsellors, and the captains, have consulted together to establish a royal statute, and to make a firm decree, that whosoever shall ask a petition of any God or man for thirty days, save of thee, O king, he shall be cast unto the den of lions.

8 Now, O king, establish the decree, and sign the writing, that it be not changed, according to the law of the Medes and Persians, which altereth not.

9 Wherefore King Darius signed the writing and the decree.

10 Now when Daniel knew that the writing was signed, he went into his house; and his windows being open in his chamber toward Jerusalem, he kneeled upon his knees three times a day, and prayed, and gave thanks before his God, as he did aforetime.

11 Then these men assembled; and found Daniel praying and making supplication before his God.

12 Then they came near, and spake before the king concerning the king's decree; Hast thou not signed a decree, that every man that shall ask *a petition* of any God or man within thirty days, save of thee, O king, shall be cast into the den of lions? The king answered and said, The thing *is* true, according to the law of the Medes and Persians, which altereth not.

13 Then answered they and said before the king, That Daniel, which *is* of the children of the captivity of Judah, regardeth not thee, O king, nor the decree that thou has signed, but maketh his petition three times a day.

14 Then the king, when he heard *these* words, was sore displeased with himself, and set *his* heart on Daniel to deliver him: and he laboured till the going down of the sun to deliver him.

15 Then these men assembled unto the king, and said unto the king, Know, O king, that the law of the Medes and Persians *is*, That no decree nor statute which the king establisheth may be changed.

16 Then the king commanded, and they brought Daniel and cast *him* into the den of lions. *Now* the king spake and said unto Daniel, Thy God whom thou servest continually, he will deliver thee.

17 And a stone was brought, and laid upon the mouth of the den; and the king sealed it with his own signet, and with the signet of his lords; that the purpose might not be changed concerning Daniel.

18 Then the king went to his palace, and passed the night fasting: neither were instruments of musick brought before him: and his sleep went from him.

19 Then the king arose very early in

the morning, and went in haste unto the den of lions.

20 And when he came to the den, he cried with a lamentable voice unto Daniel: *and* the king spake and said to Daniel, O Daniel, servant of the living God, is thy God, whom thou servest continually, able to deliver thee from the lions?

21 Then said Daniel unto the king, O king, live for ever.

22 My God hath sent his angel, and hath shut the lions' mouths, that they have not hurt me: forasmuch as before him innocency was found in me; and also before thee, O king, have I done no hurt.

23 Then was the king exceeding glad for him, and commanded that they should take Daniel up out of the den. So Daniel was taken up out of the den, and no manner of hurt was found upon him, because he believed in his God.

24 And the king commanded, and they brought those men which had accused Daniel, and they cast *them* into the den of lions, them, their children, and their wives; and the lions had the mastery of them, and brake all their bones in pieces or ever they came at the bottom of the den.

25 Then King Darius wrote unto all people, nations, and languages, that dwell in all the earth; Peace be multiplied unto you.

26 I make a decree, That in every dominion of my kingdom men tremble and fear before the God of Daniel: for he *is* the living God, and stedfast for ever, and his kingdom *that* which shall not be destroyed, and his dominion *shall be even* unto the end.

27 He delivereth and rescueth, and he worketh signs and wonders in heaven and in earth, who hath delivered Daniel from the power of the lions.

28 So this Daniel prospered in the reign of Darius, and in the reign of Cyrus the Persian.

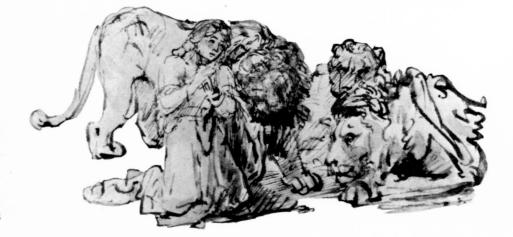

Opposite: Daniel in the Lions' Den oil on canvas David Teniers, the Elder Flemish, 1582-2649 Left: Daniel in the Lions' Den detail watercolor Rembrandt Harmensz. van Ryn Dutch, 1606-1669

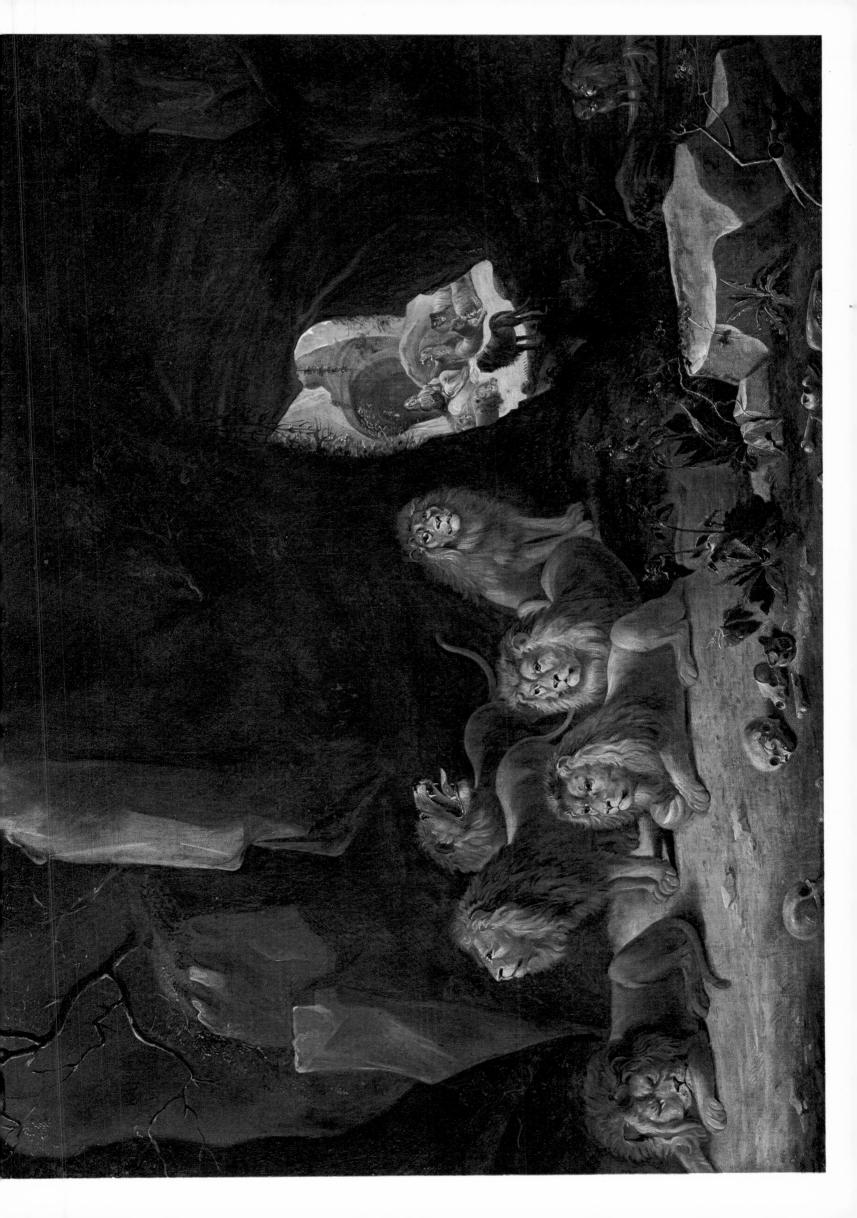

JONAH 1 & 2

19

CHAPTER 1

ow the word of the Lord came unto Jonah the son of Amittai, saying, 2 Arise, go to Nineveh,

that great city, and cry against it; for their wickedness is come up before me.

3 But Jonah rose up to flee unto Tarshish from the presence of the Lord, and went down to Joppa; and he found a ship going to Tarshish: so he paid the fare thereof, and went down into it, to go with them unto Tarshish from the presence of the Lord.

4 But the Lord sent out a great wind into the sea, and there was a mighty tempest in the sea, so that the ship was like to be broken.

5 Then the mariners were afraid, and cried every man unto his god, and cast forth the wares that *were* in the ship into the sea, to lighten *it* of them. But Jonah was gone down into the sides of the ship; and he lay, and was fast asleep.

6 So the shipmaster came to him, and said unto him, What meanest thou, O sleeper? arise, call upon thy God, if so be that God will think upon us, that we perish not.

7 And they said every one to his fellow, Come, and let us cast lots, that we may know for whose cause this evil *is* upon us. So they cast lots, and the lot fell upon Jonah.

8 Then said they unto him, Tell us, we pray thee, for whose cause this evil *is* upon us; What *is* thine occupation? and whence comest thou? what *is* thy country? and of what people *art* thou?

9 And he said unto them, I *am* an Hebrew; and I fear the Lord, the God of heaven, which hath made the sea and the dry *land*.

10 Then were the men exceedingly afraid, and said unto him, Why hast thou done this? For the men knew that he fled from the presence of the Lord, because he had told them.

11 Then said they unto him, What shall we do unto thee, that the sea may be calm unto us? for the sea wrought, and was tempestuous.

12 And he said unto them, Take me up, and cast me forth into the sea; so shall the sea be calm unto you: for I know that for my sake this great tempest *is* upon you.

13 Nevertheless the men rowed hard to bring *it* to the land; but they could not: for the sea wrought, and was tempestuous against them.

14 Wherefore they cried unto the Lord, and said, We beseech thee, O Lord, we beseech thee, let us not perish for this man's life, and lay not upon us innocent blood: for thou, O Lord, hast done as it pleased thee.

15 So they took up Jonah, and cast him forth into the sea: and the sea ceased from her raging.

16 Then the men feared the Lord exceedingly, and offered a sacrifice unto the Lord, and made vows.

17 Now the Lord had prepared a great fish to swallow up Jonah. And Jonah was in the belly of the fish three days and three nights.

CHAPTER 2

/ hen Jonah prayed unto the Lord his God out of the fish's belly,

2 And said, I cried by reason of mine affliction unto the Lord, and he heard me; out of the belly of hell

cried I, and thou heardest my voice. 3 For thou hadst cast me into the

deep, in the midst of the seas; and the floods compassed me about: all thy billows and thy waves passed over me.

4 Then I said, I am cast out of thy sight; yet I will look again toward thy holy temple.

5 The waters compassed me about, *even* to the soul: the depth closed me round about, the weeds were wrapped about my head.

6 I went down to the bottoms of the mountains; the earth with her bars *was* about me for ever: yet hast thou brought up my life from corruption, O Lord my God.

7 When my soul fainted within me I remembered the Lord: and my prayer came in unto thee, into thine holy temple.

8 They that observe lying vanities forsake their own mercy.

9 But I will sacrifice unto thee with the voice of thanksgiving; I will pay *that* that I have vowed. Salvation *is* of the Lord.

10 And the Lord spake unto the fish, and it vomited out Jonah upon the dry *land*.

Jonah and the Whale gouache on paper, illustration from Jami at-Tawarikh (Compendium of Historoies) Rashid ad Din, Fadl Allah Persian, early Timurid period, c. 1400

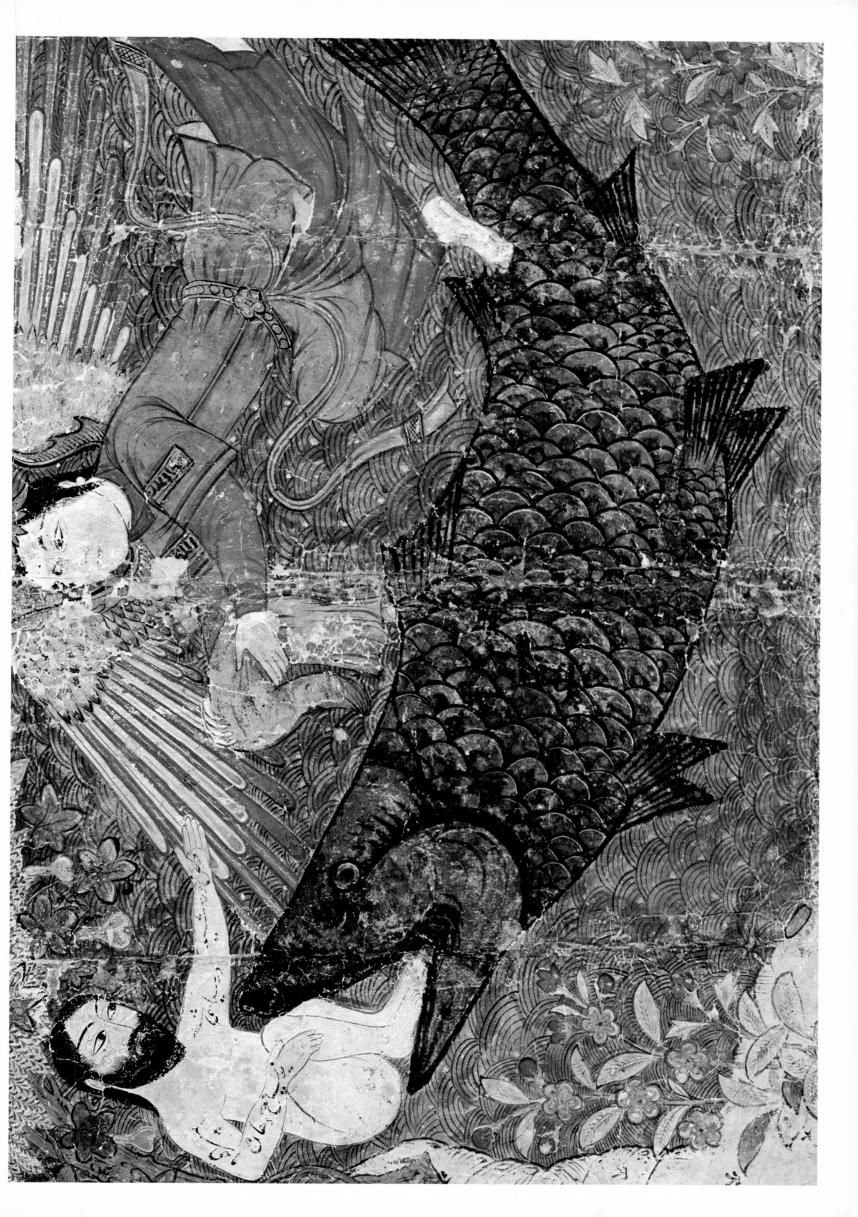

THE GOSPEL ACCORDING TO ST. LUKE 1:26-50

nd in the sixth month the angel Gabriel was sent from God unto a city of Galilee, named Nazareth, 27 To a virgin espoused to a man whose name was Joseph, of the house of David; and the virgin's name was Mary.

28 And the angel came in unto her, and said, Hail, thou that art highly favoured, the Lord is with thee: blessed art thou among women.

29 And when she saw *him*, she was troubled at his saying, and cast in her mind what manner of salutation this should be.

30 And the angel said unto her, Fear not, Mary: for thou hast found favour with God.

31 And, behold, thou shalt conceive in thy womb, and bring forth a son, and shalt call his name JESUS.

32 He shall be great, and shall be called the Son of the Highest: and the Lord God shall give unto him the throne of his father David;

33 And he shall reign over the house of Jacob for ever; and of his kingdom there shall be no end.

34 Then said Mary unto the angel, How shall this be, seeing I know not a man? 35 And the angel answered and said unto her, The Holy Ghost shall come upon thee, and the power of the Highest shall overshadow thee: therefore also that holy thing which shall be born of thee shall be called the Son of God.

36 And, behold, thy cousin Elisabeth, she hath also conceived a son in her old age: and this is the sixth month with her, who was called barren.

37 For with God nothing shall be impossible.

38 And Mary said, Behold the handmaid of the Lord; be it unto me according to thy word. And the angel departed from her.

39 And Mary arose in those days, and went into the hill country with haste, into a city of Juda;

40 And entered into the house of Zacharias, and saluted Elisabeth.

41 And it came to pass, that, when Elisabeth heard the salutation of Mary, the babe leaped in her womb; and Elisabeth was filled with the Holy Ghost:

42 And she spake out with a loud voice, and said, Blessed *art* thou among women, and blessed *is* the fruit of thy womb.

43 And whence *is* this to me, that the mother of my Lord should come to me?

44 For, lo, as soon as the voice of thy salutation sounded in mine ears, the babe leaped in my womb for joy.

45 And blessed *is* she that believed: for there shall be a performance of those things which were told her from the Lord.

46 And Mary said, My soul doth magnify the Lord,

47 And my spirit hath rejoiced in God my Saviour.

48 For he hath regarded the low estate of his handmaiden: for, behold, from henceforth all generations shall call me blessed.

49 For he that is mighty hath done to me great things; and holy *is* his name.

50 And his mercy *is* on them that fear him from generation to generation.

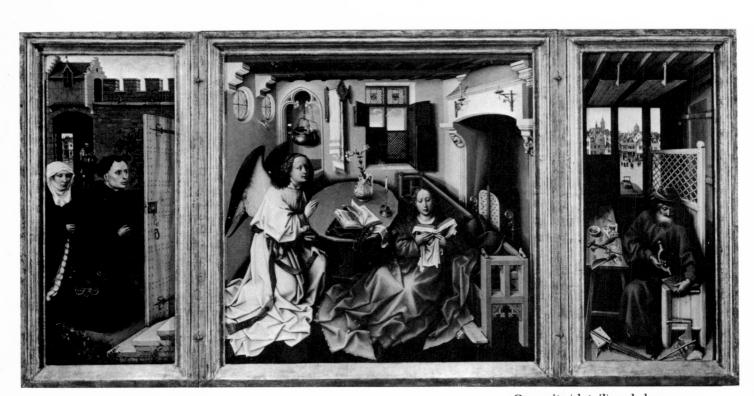

Opposite (detail) and above: *The Annunciation* triptych oil on wood Robert Campin Flemish, b.?-1444

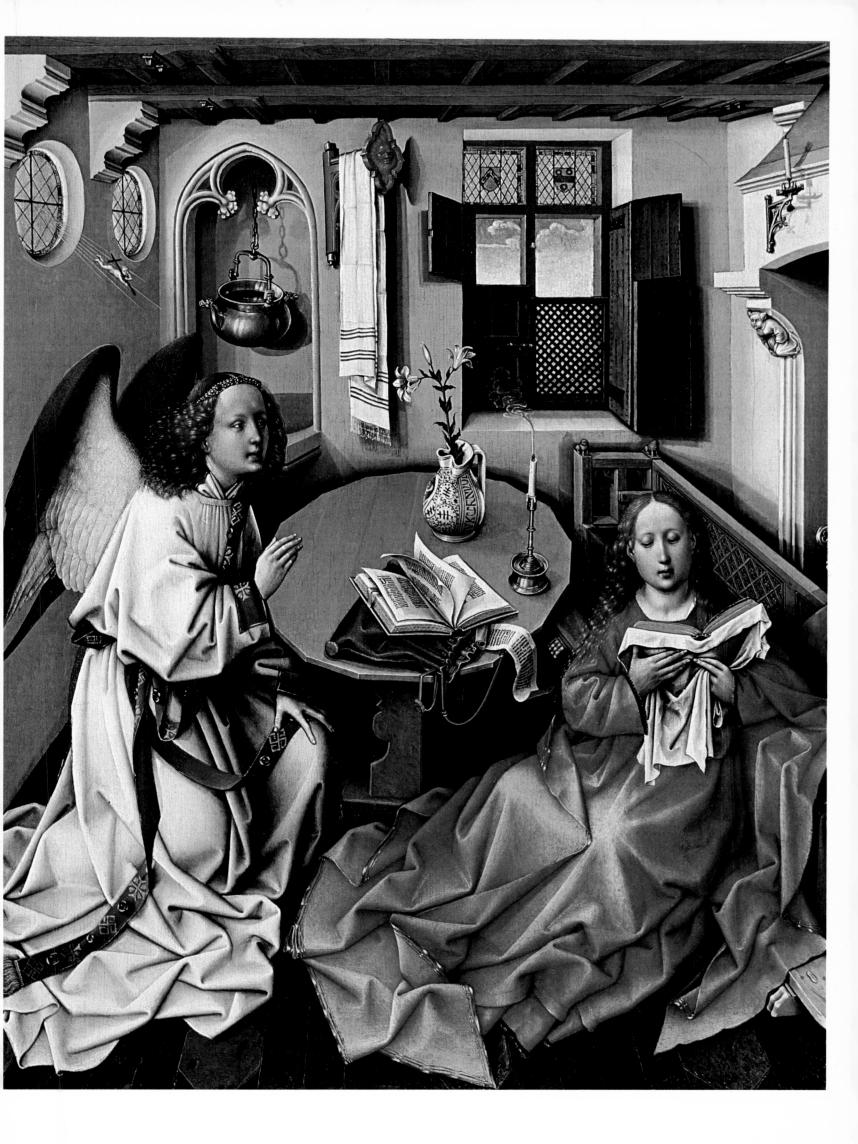

THE GOSPEL ACCORDING TO ST. MATTHEW 2:1-12

ow when Jesus was born in Bethehem of Judaea in the days of Herod the king, behold, there came wise men from the east to Jerusalem,

2 Saying, Where is he that is born King of the Jews? for we have seen his star in the east, and are come to worship him.

3 When Herod the king had heard *these things*, he was troubled, and all Jerusalem with him.

4 And when he had gathered all the chief priests and scribes of the people together, he demanded of them where Christ should be born. 5 And they said unto him, In Bethlehem of Judaea: for thus it is written by the prophet,

6 And thou Bethlehem, *in* the land of Juda, art not the least among the princes of Juda: for out of thee shall come a Governor, that shall rule my people Israel.

7 Then Herod, when he had privily called the wise men, enquired of them diligently what time the star appeared.

8 And he sent them to Bethlehem, and said, Go and search diligently for the young child; and when ye have found *him*, bring me word again, that I may come and worship him also.

9 When they had heard the king,

they departed; and, lo, the star, which they saw in the east, went before them, till it came and stood over where the young child was.

10 When they saw the star, they rejoiced with exceeding great joy.

11 And when they were come into the house, they saw the young child with Mary his mother, and fell down, and worshipped him: and when they had opened their treasures, they presented unto him gifts; gold, and frankincense, and myrrh.

12 And being warned of God in a dream that they should not return to Herod, they departed into their own country another way.

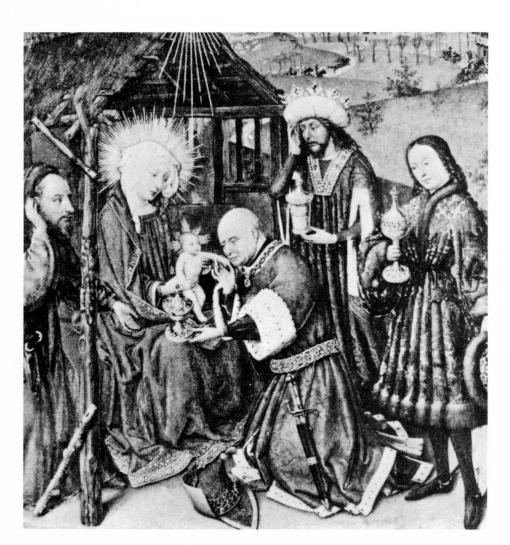

Opposite: *The Adoration of the Magi* tempera and oil on wood Hieronymus Bosch Flemish, b.?-1516 Left:

The Wise Men Come From the East oil on canvas artist unknown Flemish School, fifteenth century

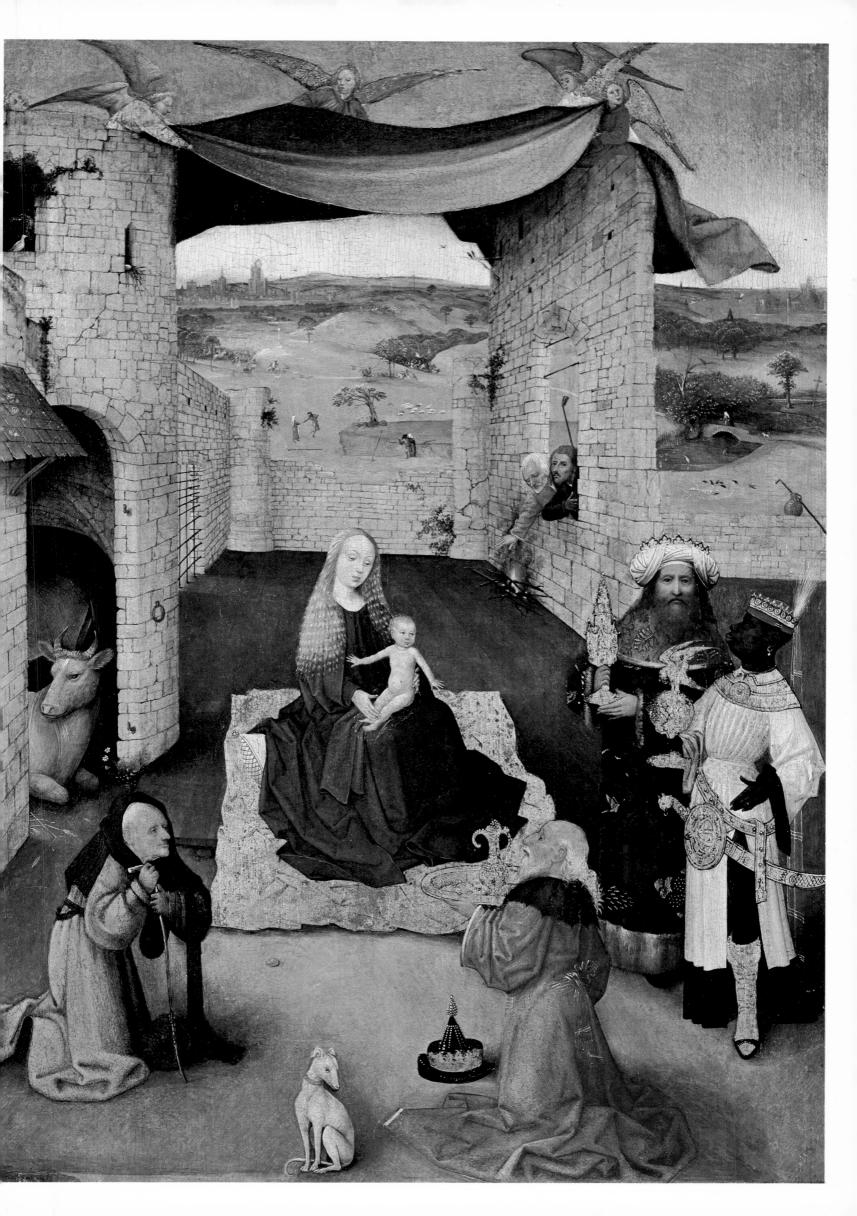

THE GOSPEL ACCORDING TO ST. LUKE 2:21-40

nd when eight days were accomplished for the circumcising of the child, his name was called JESUS, which was so named of the angel before he was conceived in the womb.

22 And when the days of her purification according to the law of Moses were accomplished, they brought him to Jerusalem, to present *him* to the Lord;

23 (As it is written in the law of the Lord, Every male that openeth the womb shall be called holy to the Lord;)

24 And to offer a sacrifice according to that which is said in the law of the Lord, A pair of turtledoves, or two young pigeons.

25 And, behold, there was a man in Jerusalem, whose name *was* Simeon; and the same man *was* just and devout, waiting for the consolation of Israel: and the Holy Ghost was upon him.

26 And it was revealed unto him by the Holy Ghost, that he should not see death, before he had seen the Lord's Christ.

27 And he came by the Spirit into the temple: and when the parents brought in the child Jesus, to do for him after the custom of the law,

28 Then took he him up in his arms, and blessed God, and said,

29 Lord, now lettest thou thy servant depart in peace, according to thy word:

30 For mine eyes have seen thy salvation,

31 Which thou hast prepared before the face of all people;

32 A light to lighten the Gentiles, and the glory of thy people Israel.

33 And Joseph and his mother marvelled at those things which were spoken of him.

34 And Simeon blessed them, and said unto Mary his mother, Behold, this *child* is set for the fall and rising again of many in Israel; and for a sign which shall be spoken against;

35 (Yea, a sword shall pierce through thy own soul also,) that the thoughts of many hearts may be revealed.

36 And there was one Anna, a prophetess, the daughter of Phanuel, of the tribe of Aser: she was of a great age, and had lived with an husband seven years from her virginity;

37 And she *was* a widow of about forescore and four years, which departed not from the temple, but served *God* with fastings and prayers night and day.

38 And she coming in that instant gave thanks likewise unto the Lord, and spake of him to all them that looked for redemption in Jerusalem.

39 And when they had performed all things according to the law of the Lord, they returned into Galilee, to their own city Nazareth.

40 And the child grew, and waxed strong in spirit, filled with wisdom: and the grace of God was upon him.

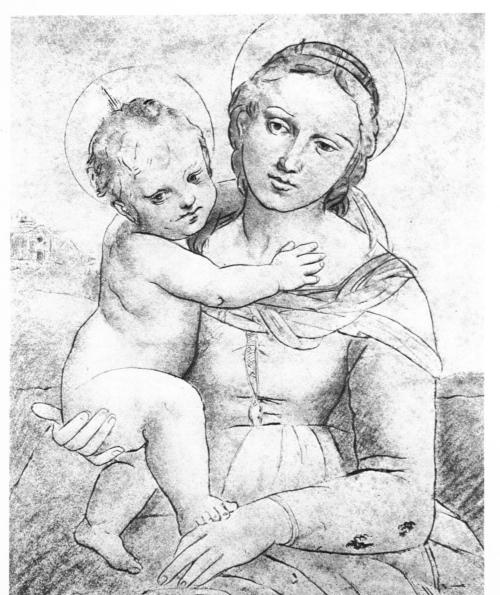

Opposite: *Madonna della Sedia* oil on canvas Raphaël (Raffaello Sanzio) Italian, 1483-1520 Left: *Madonna and Child* drawing Raphaël (Raffaello Sanzio) Italian, 1483-1520

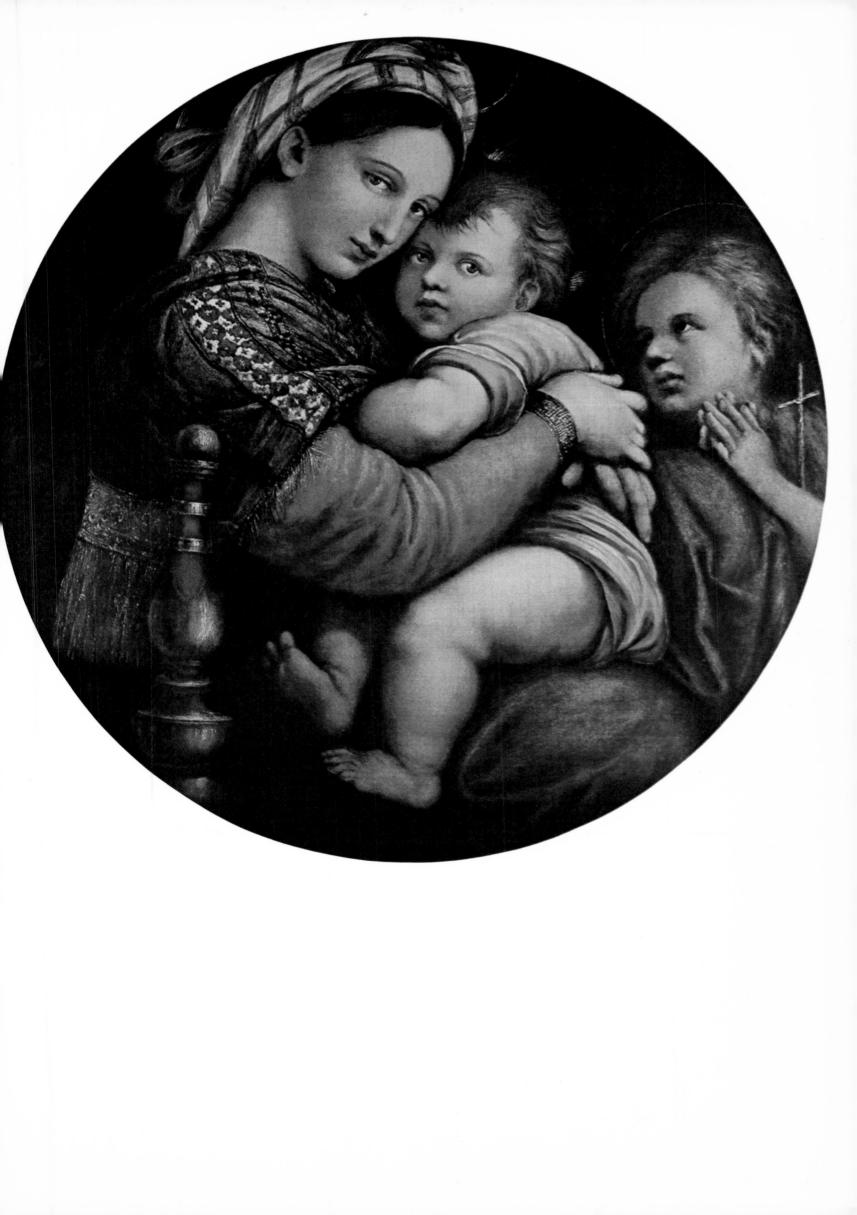

THE GOSPEL ACCORDING TO ST. MATTHEW 13:55-57

s not this the carpenter's son? Is not his mother called Mary? and his brethren, James, and Joses, and Simon, and Judas? with us? Whence then hath this *man* all these things?

57 And they were offended in him. But Jesus said unto them, A prophet is not without honour, save in his own country, and in his own house.

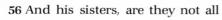

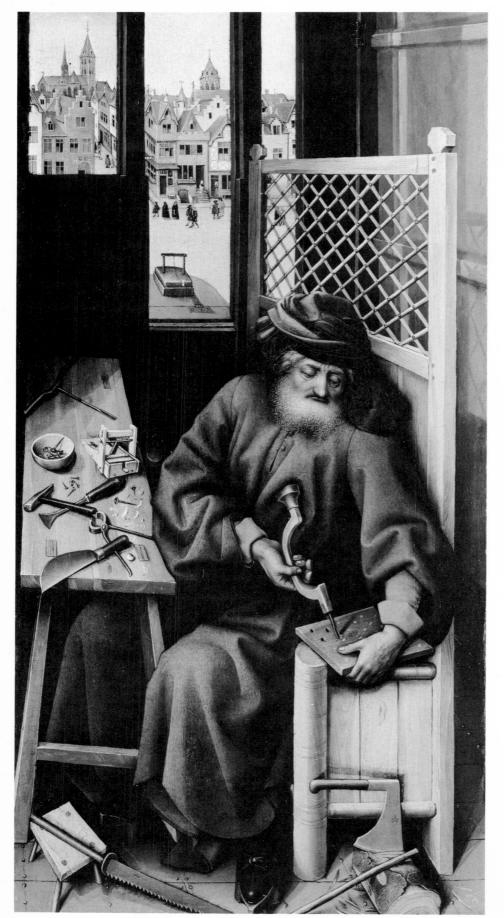

Opposite: Joseph the Carpenter oil on canvas Georges de la Tour French, 1593-1652 Left: St. Joseph detail, the Merode Altarpiece oil on wood Robert Campin Flemish, b. ?-1444

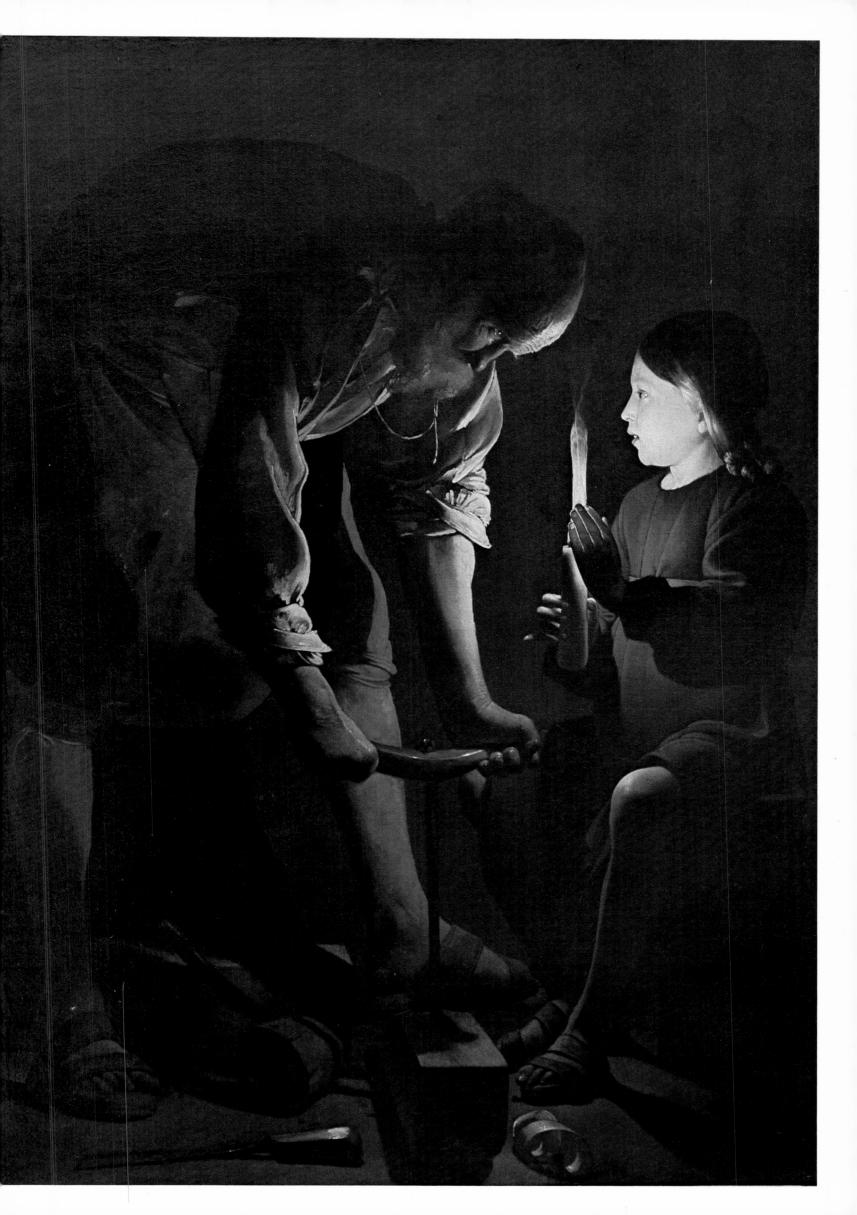

THE GOSPEL ACCORDING TO ST. JOHN 2:1-11

nd the third day there was a marriage in Cana of Galilee; and the mother of Jesus was there: 2 And both Jesus was

called, and his disciples, to the marriage.

3 And when they wanted wine, the mother of Jesus saith unto him, They have no wine.

4 Jesus saith unto her "Woman, what have I to do with thee? mine hour is not yet come."

5 His mother saith unto the ser-

vants, Whatsoever he saith unto you, do it.

6 And there were set there six waterpots of stone, after the manner of the purifying of the Jews, containing two or three firkins apiece.

7 Jesus saith unto them, "Fill the waterpots with water." And they filled them up to the brim.

8 And he saith unto them, "Draw out now, and bear unto the governor of the feast." And they bare *it*.

9 When the ruler of the feast had tasted the water that was made wine,

and knew not whence it was: (but the servants which drew the water knew;) the governor of the feast called the bridegroom,

10 And saith unto him, Every man at the beginning doth set forth good wine; and when men have well drunk, then that which is worse: *but* thou hast kept the good wine until now.

11 This beginning of miracles did Jesus in Cana of Galilee, and manifested forth his glory; and his disciples believed on him.

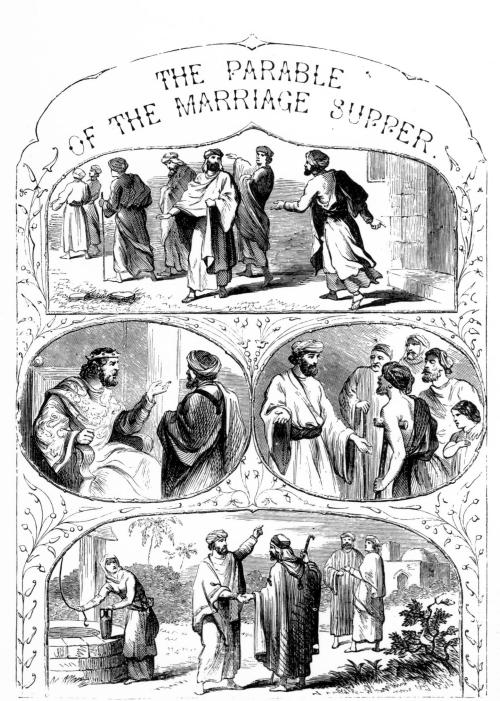

Opposite: *The Marriage at Cana* oil on canvas Gerard David Flemish, 1460-1524 Left: *The Parable of the Marriage Supper* engraving artist unknown English, nineteenth century

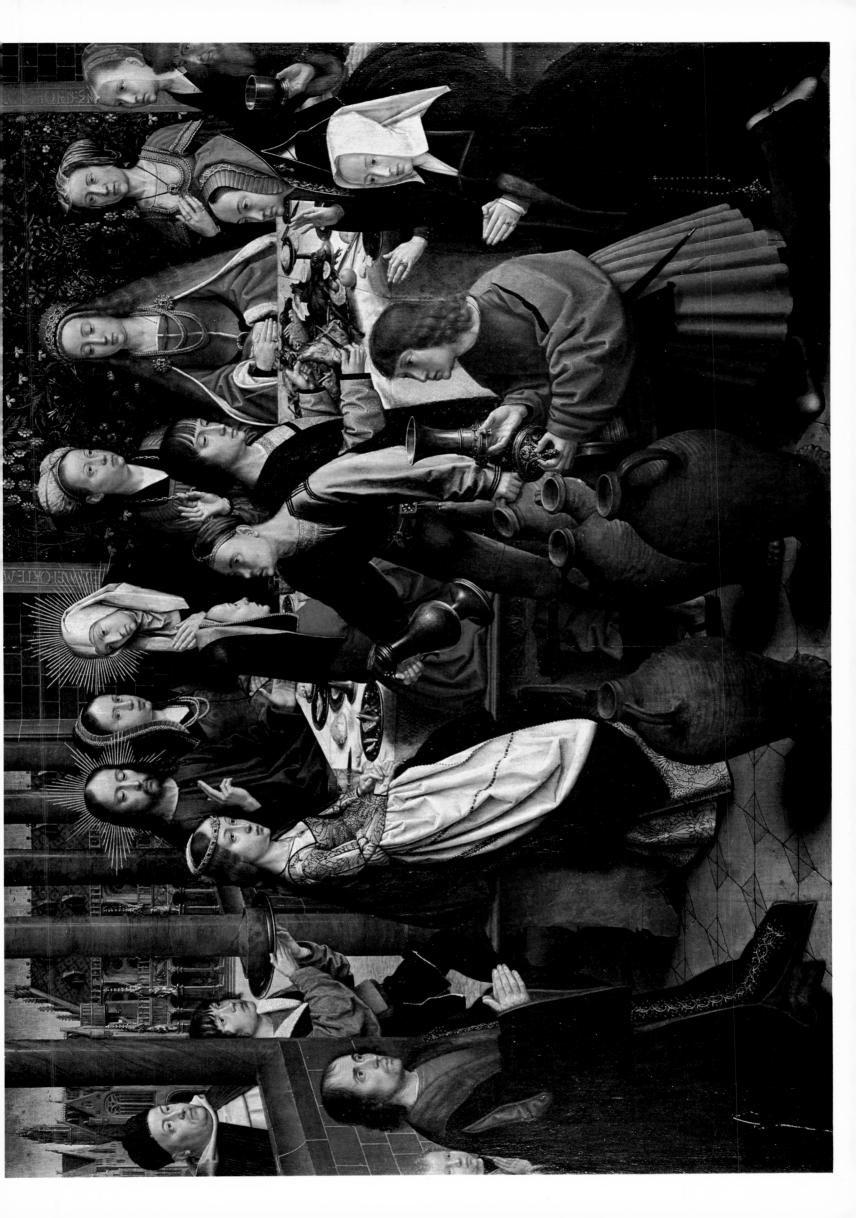

THE GOSPEL ACCORDING TO ST. MATTHEW 5

H

nd seeing the multitudes, he went up into a mountain: and when he was set, his disciples came unto him:

2 And he opened his mouth, and taught them, saying,

3 Blessed *are* the poor in spirit: for their's is the kingdom of heaven.

4 Blessed *are* they that mourn: for they shall be comforted.

5 Blessed *are* the meek: for they shall inherit the earth.

6 Blessed *are* they which do hunger and thirst after righteousness: for they shall be filled.

7 Blessed *are* the merciful: for they shall obtain mercy.

8 Blessed *are* the pure in heart: for they shall see God.

9 Blessed *are* the peacemakers: for they shall be called the children of God.

10 Blessed *are* they which are persecuted for righteousness' sake: for their's is the kingdom of heaven.

11 Blessed are ye, when *men* shall revile you, and persecute *you*, and shall say all manner of evil against you falsely, for my sake. **12** Rejoice, and be exceeding glad: for great *is* your reward in heaven: for so persecuted they the prophets which were before you.

13 Ye are the salt of the earth: but if the salt have lost his savour, wherewith shall it be salted? it is thenceforth good for nothing, but to be cast out, and to be trodden under foot of men.

14 Ye are the light of the world. A city that is set on an hill cannot be hid.

15 Neither do men light a candle, and put it under a bushel, but on a candlestick; and it giveth light unto all that are in the house.

16 Let your light so shine before men, that they may see your good works, and glorify your Father which is in heaven.

17 Think not that I am come to destroy the law, or the prophets: I am not come to destroy, but to fulfil.

18 For verily I say unto you, Till heaven and earth pass, one jot or one tittle shall in no wise pass from the law, till all be fulfilled.

19 Whosoever therefore shall break one of these least commandments,

and shall teach men so, he shall be called the least in the kingdom of heaven: but whosoever shall do and teach *them*, the same shall be called great in the kingdom of heaven.

20 For I say unto you, That except your righteousness shall exceed *the righteousness* of the scribes and Pharisees, ye shall in no case enter into the kingdom of heaven.

21 Ye have heard that it was said by them of old time, Thou shalt not kill; and whosoever shall kill shall be in danger of the judgment:

22 But I say unto you, That whosoever is angry with his brother without a cause shall be in danger of the judgment: and whosoever shall say to his brother, Raca, shall be in danger of the council: but whosoever shall say, Thou fool, shall be in danger of hell fire.

23 Therefore if thou bring thy gift to the altar, and there rememberest that thy brother hath ought against thee;

24 Leave there thy gift before the altar, and go thy way; first be reconciled to thy brother, and then come and offer thy gift.

Head of Christ oil on canvas Rembrandt Harmensz. van Ryn Dutch, 1606-1669

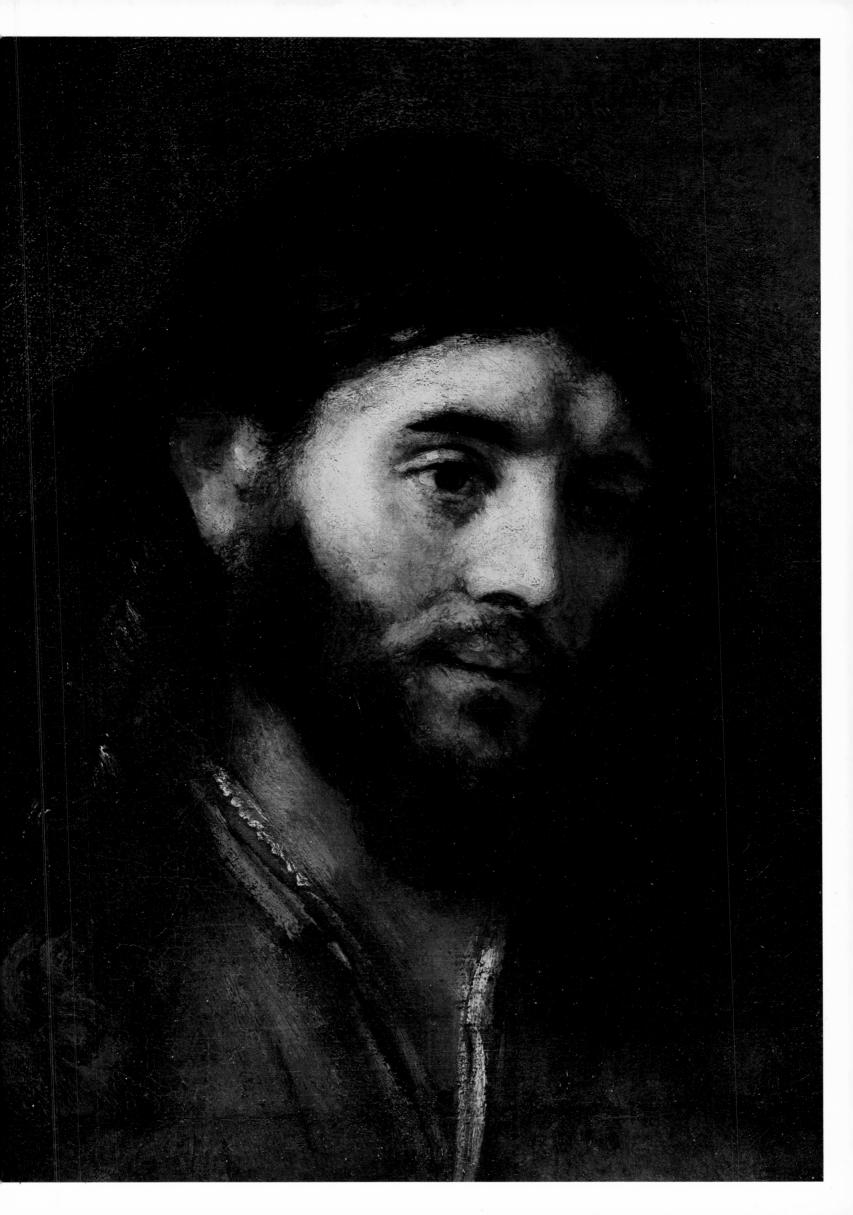

THE GOSPEL ACCORDING TO ST. MATTHEW 6:5-13

nd when thou prayest, thou shalt not be as the hypocrites *are*: for they love to pray standing in the synagogues and in the corners of the streets, that they may be seen of men. Verily I say unto you, They have their reward.

6 But thou, when thou prayest, enter into thy closet, and when thou hast shut thy door, pray to thy Father which is in secret; and thy Father which seeth in secret shall reward thee openly.

7 But when ye pray, use not vain repetitions, as the heathen *do*: for they think that they shall be heard for their much speaking.

8 Be not ye therefore like unto them: for your Father knoweth what things ye have need of, before ye ask him.

9 After this manner therefore pray ye: Our Father which art in heaven, Hallowed be thy name.

10 Thy kingdom come. Thy will be done in earth, as *it is* in heaven.

11 Give us this day our daily bread. 12 And forgive us our debts, as we forgive our debtors.

13 And lead us not into temptation, but deliver us from evil: For thine is the kingdom, and the power, and the glory, for ever. Amen.

Opposite: Praying Hands engraving Albrecht Dürer German, 1471-1528 Left: The Sermon on the Mount detail engraving Paul Gustave Doré French, 1833-1883

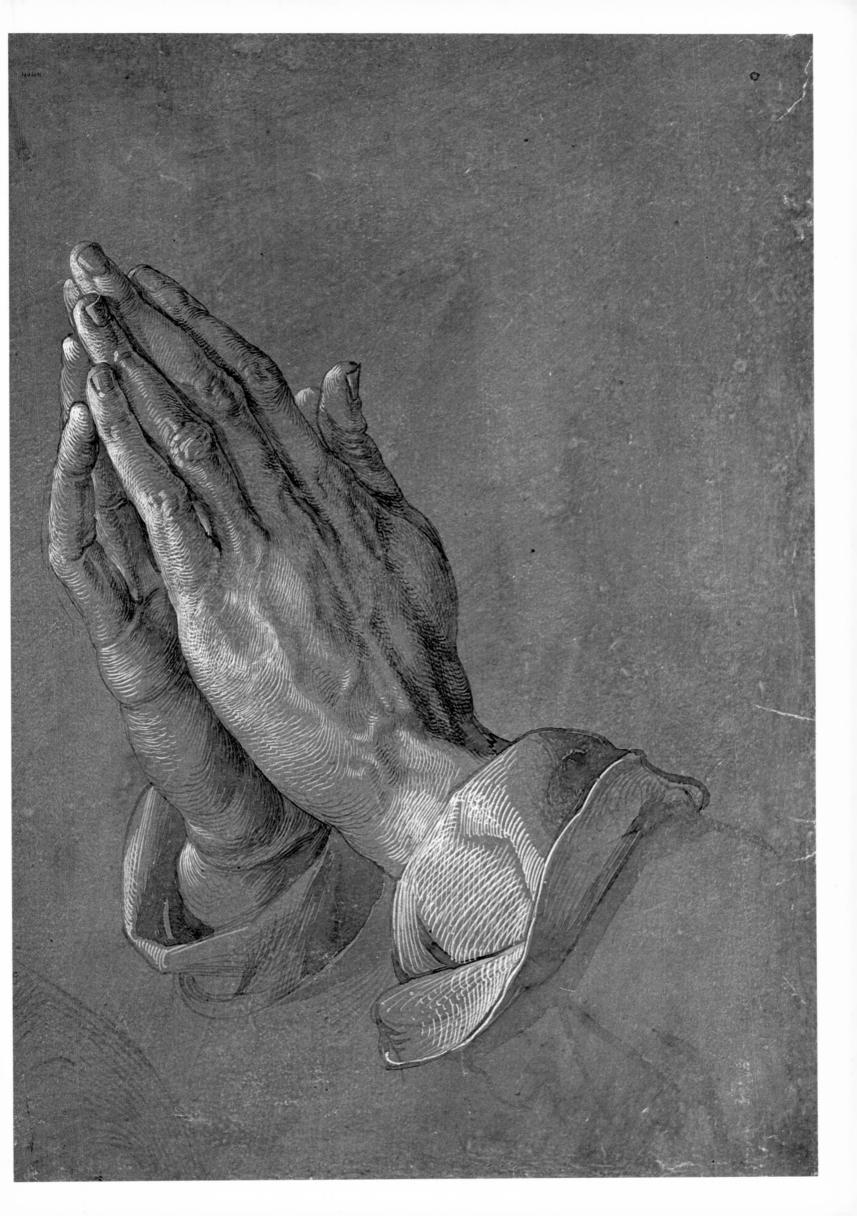

THE GOSPEL ACCORDING TO ST. MARK 9:2-40

nd after six days Jesus taketh with him Peter, and James, and John, and leadeth them up into an high mountain apart by themselves: and he was transfigured before them.

3 And his raiment became shining, exceeding white as snow; so as no fuller on earth can white them.

4 And there appeared unto them Elias with Moses: and they were talking with Jesus.

5 And Peter answered and said to Jesus, Master, it is good for us to be here: and let us make three tabernacles; one for thee, and one for Moses, and one for Elias.

6 For he wist not what to say; for they were sore afraid.

7 And there was a cloud that overshadowed them: and a voice came out of the cloud, saying, This is my beloved Son: hear him.

8 And suddenly, when they had looked round about, they saw no man any more, save Jesus only with themselves.

9 And as they came down from the mountain, he charged them that they should tell no man what things they had seen, till the Son of man were risen from the dead.

10 And they kept that saying with themselves, questioning one with another what the rising from the dead should mean.

11 And they asked him, saying, Why say the scribes that Elias must first come?

12 And he answered and told them, Elias verily cometh first, and restoreth all things; and how it is written of the Son of man, that he must suffer many things, and be set at nought.

13 But I say unto you, That Elias is indeed come, and they have done unto him whatsoever they listed, as it is written of him.

14 And when he came to *his* disciples, he saw a great multitude about

them, and the scribes questioning with them.

15 And straightway all the people, when they beheld him, were greatly amazed, and running to *him* saluted him.

16 And he asked the scribes, What question ye with them?

17 And one of the multitude answered and said, Master, I have brought unto thee my son, which hath a dumb spirit;

18 And whatsoever he taketh him, he teareth him: and he foameth, and gnasheth with his teeth, and pineth away: and I spake to thy disciples that they should cast him out; and they could not.

19 He answereth him, and saith, O faithless generation, how long shall I be with you? how long shall I suffer you? bring him unto me.

20 And they brought him unto him: and when he saw them, straightway the spirit tare him; and he fell on the ground, and wallowed foaming.

21 And he asked his father, How long is it ago since this came unto him? And he said, Of a child.

22 And offtimes it hath cast him into the fire, and into the waters, to destroy him: but if thou canst do any thing, have compassion on us, and help us.

23 Jesus said unto him, If thou canst believe, all things *are* possible to him that believeth.

24 And straightway the father of the child cried out, and said with tears, Lord, I believe; help thou mine unbelief.

25 When Jesus saw that the people came running together, he rebuked the foul spirit, saying unto him, *Thou* dumb and deaf spirit, I charge thee, come out of him, and enter no more into him.

26 And *the spirit* cried, and rent him sore, and came out of him: and he was as one dead; insomuch that many said, He is dead. 27 But Jesus took him by the hand, and lifted him up; and he arose.

28 And when he was come into the house, his disciples asked him privately, Why could not we cast him out?

29 And he said unto them, This kind can come forth by nothing, but by prayer and fasting.

30 And they departed thence, and passed through Galilee; and he would not that any man should know *it*.

31 For he taught his disciples, and said unto them, The Son of man is delivered into the hands of men, and they shall kill him; and after that he is killed, he shall rise the third day.

32 But they understood not that saying, and were afraid to ask him.

33 And he came to Capernaum: and being in the house he asked them. What was it that ye disputed among yourselves by the way?

34 But they held their peace: for by the way they had disputed among themselves, who *should be* the greatest.

35 And he sat down, and called the twelve, and saith unto them. If any man desire to be first, *the same* shall be last of all, and servant of all.

36 And he took a child, and set him in the midst of them: and when he had taken him in his arms, he said unto them,

37 Whosoever shall receive one of such children in my name, receiveth me: and whosoever shall receive me, receiveth not me, but him that sent me.

38 And John answered him, saying, Master, we saw one casting out devils in thy name, and he followeth not us: and we forbad him, because he followeth not us.

39 But Jesus said, Forbid him not: for there is no man which shall do a miracle in my name, that can lightly speak evil of me.

40 For he that is not against us is on our part.

Opposite: *The Transfiguration* oil on canvas Raphaël (Raffaello Sanzio) Italian, 1483-1520

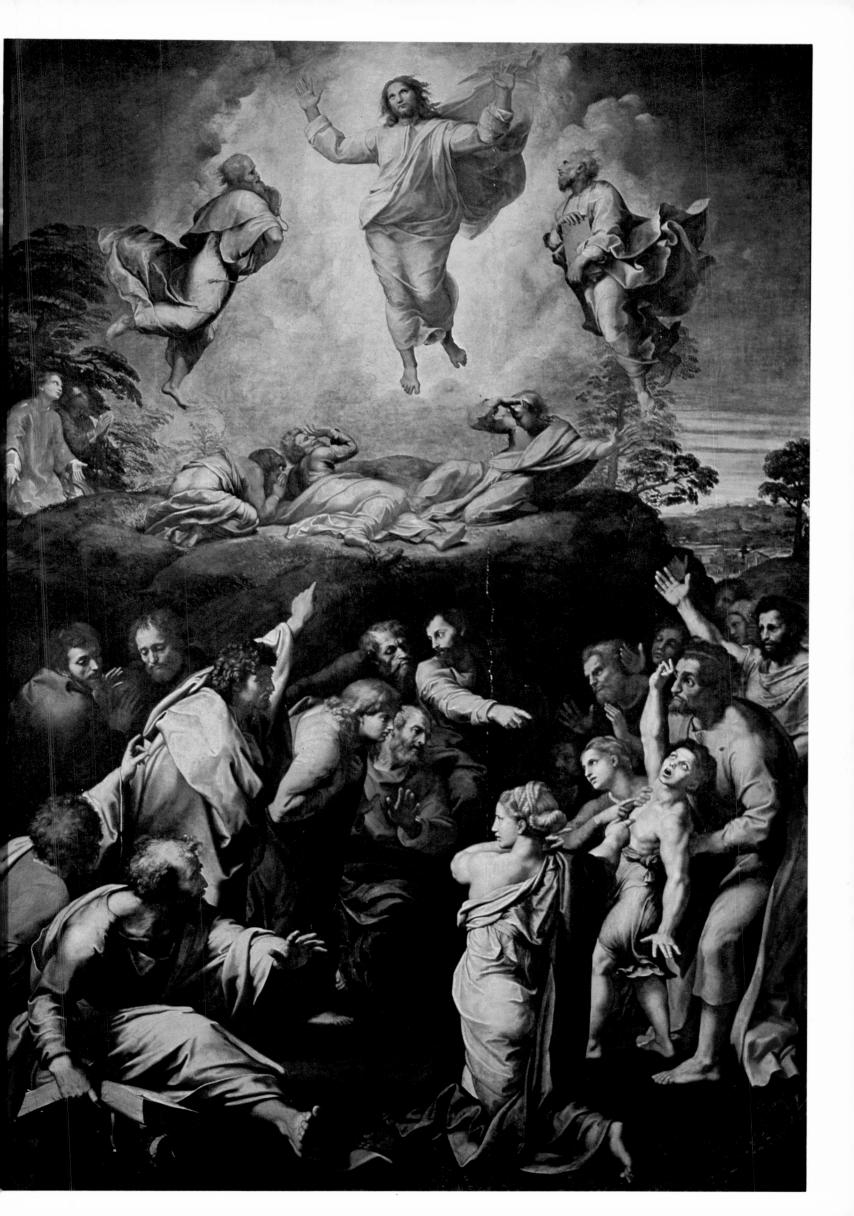

THE GOSPEL ACCORDING TO ST. MARK 10:13-16

nd they brought young children to him, that he should touch them: and *his* disciples rebuked those that brought *them*. 14 But when Jesus saw

it, he was much displeased, and said unto them, "Suffer the little children to come unto me, and forbid them not: for of such is the kingdom of God."

15 "Verily I say unto you, Whosoever shall not receive the kingdom of God as a little child, he shall not enter therein."

16 And he took them up in his arms, put *his* hands upon them, and blessed them.

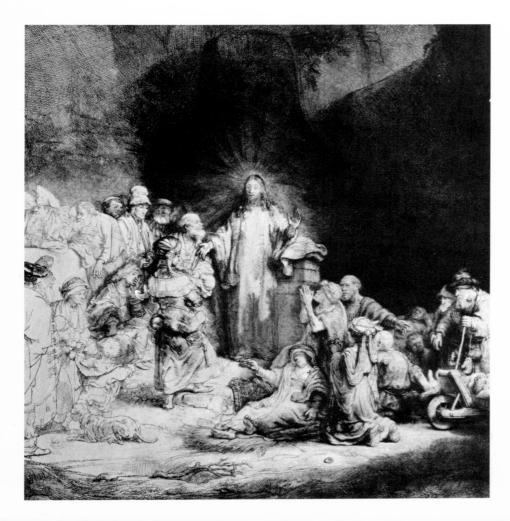

Opposite: Jesus Blessing the Children oil on canvas Bernhard Plockhorst German, 1825-1907 Left: Christ with the sick around Him, receiving little children detail etching Rembrandt Harmensz. van Ryn Dutch, 1606-1669

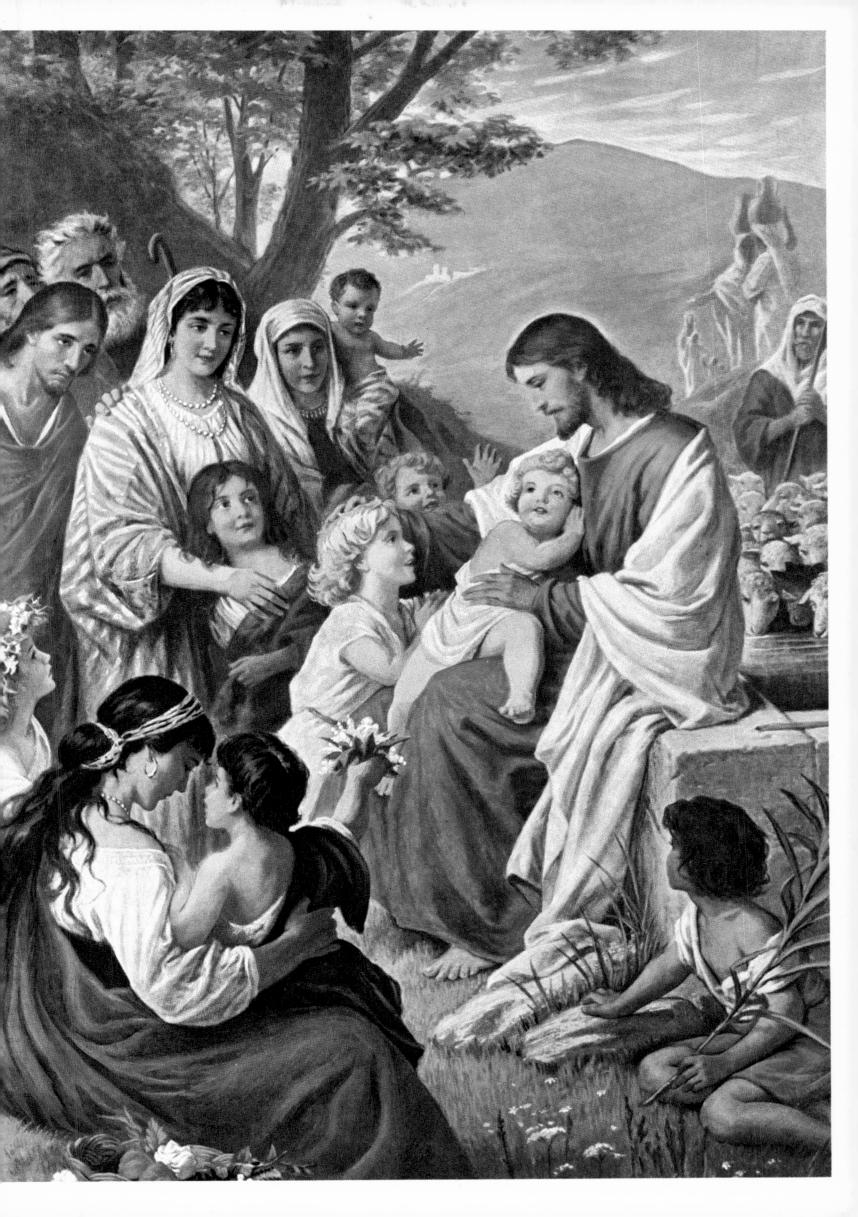

THE GOSPEL ACCORDING TO ST. MATTHEW 21:1-9

nd when they drew nigh unto Jerusalem, and were come to Bethphage, unto the mount of Olives, then sent Jesus two disciples, 2 Saying unto them, Go into the village over against you, and straightway ye shall find an ass tied, and a colt with her: loose *them*, and bring *them* unto me.

3 And if any *man* say ought unto you, ye shall say, The Lord hath need of them; and straightway he will send them.

4 All this was done, that it might be fulfilled which was spoken by the prophet, saying.

5 Tell ye the daughter of Sion,

Behold, thy King cometh unto thee, meek, and sitting upon an ass, and a colt the foal of an ass.

6 And the disciples went, and did as Jesus commanded them.

7 And brought the ass, and the colt, and put on them their clothes, and they set *him* thereon.

8 And a very great multitude spread their garments in the way; others cut down branches from the trees, and strawed *them* in the way.

9 And the multitudes that went before, and that followed, cried, saying, Hosanna to the son of David: Blessed *is* he that cometh in the name of the Lord; Hosanna in the highest.

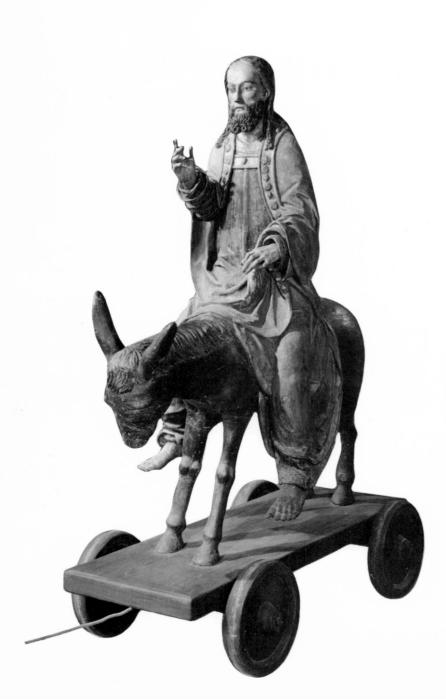

Opposite: Christ's Entry into Jerusalem oil on canvas Giotto Italian, 1266-1337 Left: Christ on a Donkey lindenwood with base artist unknown German, fifteenth century

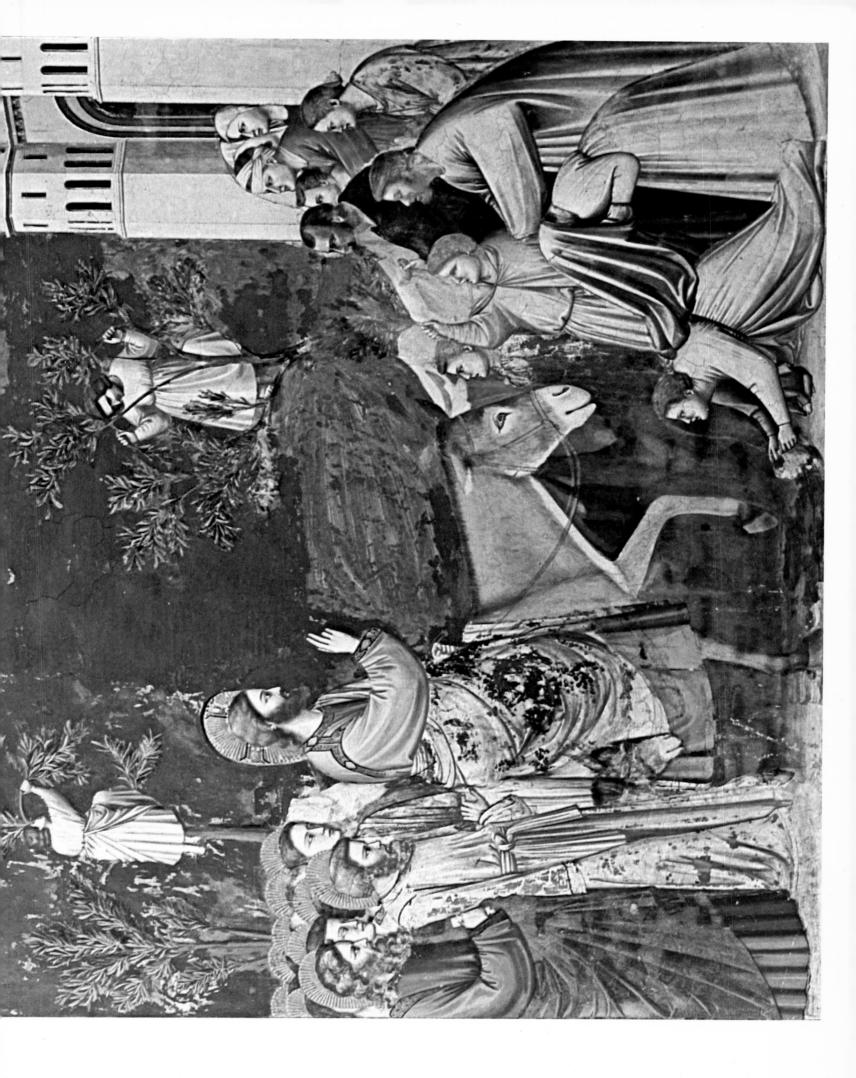

THE GOSPEL ACCORDING TO ST. MATTHEW 26:14-30

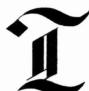

hen one of the twelve, called Judas Iscariot, went unto the chief priests,

15 And said *unto them,* What will ye give

me, and I will deliver him unto you? And they covenanted with him for thirty pieces of silver.

16 And from that time he sought opportunity to betray him.

17 Now the first *day* of the *feast of* unleavened bread the disciples came to Jesus, saying unto him, Where wilt thou that we prepare for thee to eat the passover?

18 And he said, "Go into the city to such a man, and say unto him, The Master saith, My time is at hand; I will keep the passover at thy house with my disciples." 19 And the disciples did as Jesus had appointed them; and they made ready the passover.

20 Now when the even was come, he sat down with the twelve.

21 And as they did eat, he said, "Verily I say unto you, that one of you shall betray me."

22 And they were exceeding sorrowful, and began every one of them to say unto him, Lord, is it I?

23 And he answered and said, "He that dippeth *his* hand with me in the dish, the same shall betray me."

24 "The Son of man goeth as it is written of him: but woe unto that man by whom the Son of man is betrayed! it had been good for that man if he had not been born."

25 Then Judas, which betrayed him, answered and said, Master, is it I? He

said unto him, "Thou hast said."

26 And as they were eating, Jesus took bread, and blessed *it*, and brake *it*, and gave *it* to the disciples, and said, "Take, eat; this is my body."

27 And he took the cup, and gave thanks, and gave *it* to them, saying, "Drink ye all of it;"

28 "For this is my blood of the new testament, which is shed for many for the remission of sins."

29 "But I say unto you, I will not drink henceforth of this fruit of the vine, until that day when I drink it new with you in my Father's kingdom."

30 And when they had sung an hymn, they went out into the mount of Olives.

Opposite: The Last Supper fresco Leonardo Da Vinci Italian, 1452-1519 (A recreation of the original painting after the restoration by Mauro Pellicciolio.)

Left:

The Last Supper limestone relief artist unknown Lower Rhenish School German, c.1500

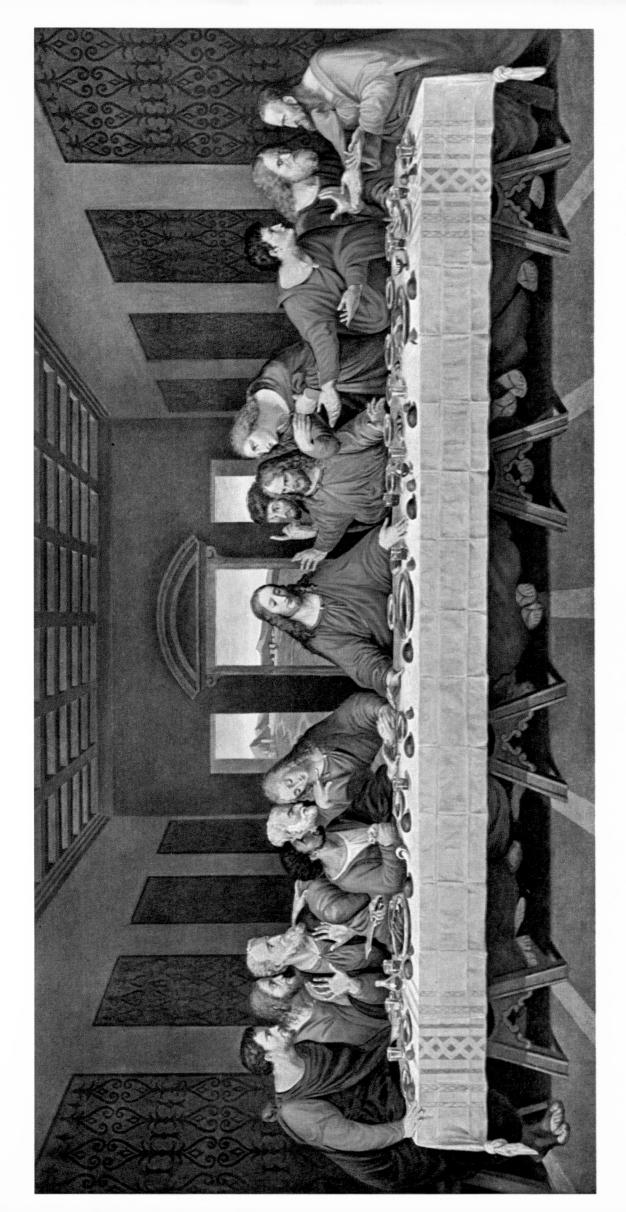

THE GOSPEL ACCORDING TO ST. MARK 14:32-46

nd they came to a place which was named Gethsemane: and he saith to his disciples, Sit ye here, while I shall pray.

33 And he taketh with him Peter and James and John, and began to be sore amazed, and to be very heavy;

34 And saith unto them, My soul is exceeding sorrowful unto death: tarry ye here, and watch.

35 And he went forward a little, and fell on the ground, and prayed that, if it were possible, the hour might pass from him.

36 And he said, Abba, Father, all things *are* possible unto thee; take

away this cup from me: nevertheless not what I will, but what thou wilt.

37 And he cometh, and findeth them sleeping, and saith unto Peter, Simon, sleepest thou? couldest not thou watch one hour?

38 Watch ye and pray, lest ye enter into temptation. The spirit truly *is* ready, but the flesh *is* weak.

39 And again he went away, and prayed, and spake the same words.

40 And when he returned, he found them asleep again, (for their eyes were heavy,) neither wist they what to answer him.

41 And he cometh the third time, and saith unto them, Sleep on now, and take *your* rest: it is enough, the hour is come; behold, the Son of man is betrayed into the hands of sinners. 42 Rise up, let us go; lo, he that

betrayeth me is at hand.

43 And immediately, while he yet spake, cometh Judas, one of the twelve, and with him a great multitude with swords and staves, from the chief priests and the scribes and the elders.

44 And he that betrayed him had given them a token, saying, Whomsoever I shall kiss, that same is he; take him, and lead *him* away safely.

45 And as soon as he was come, he goeth straightway to him, and saith, Master, master; and kissed him.

46 And they laid their hands on him, and took him.

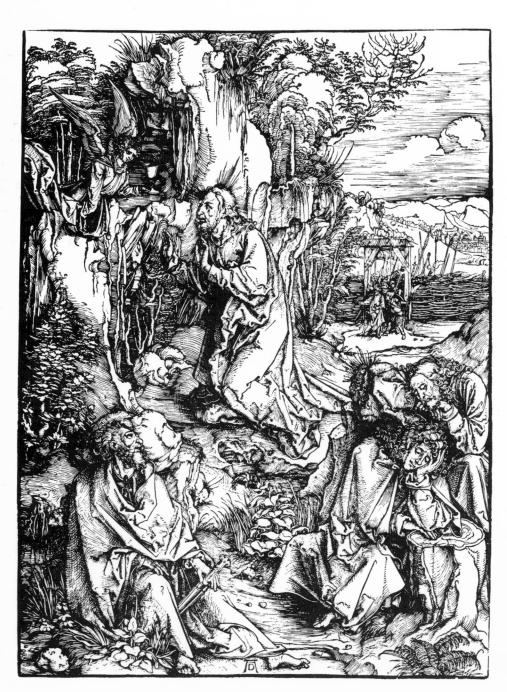

Opposite: Christ in the Garden of Gethsemane oil on canvas Heinrich Hofmann American, 1824-1911 Left: Agony in the Garden woodcut Albrecht Dürer German, 1471-1528

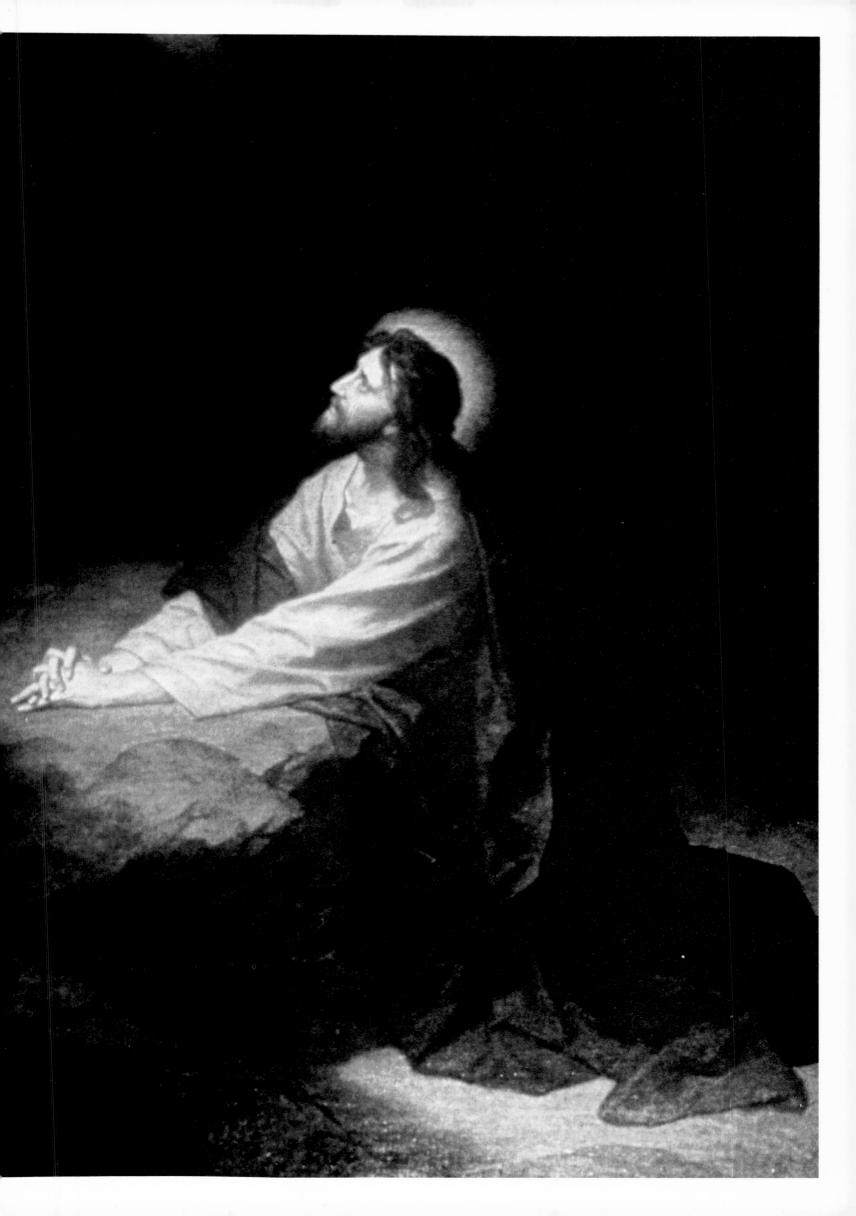

THE GOSPEL ACCORDING TO ST. JOHN 19:1-30

hen Pilate therefore took Jesus, and scourged him.

2 And the soldiers platted a crown of thorns, and put *it* on

his head, and they put on him a purple robe,

3 And said, Hail, King of the Jews! and they smote him with their hands.

4 Pilate therefore went forth again, and saith unto them, Behold, I bring him forth to you, that ye may know that I find no fault in him.

5 Then came Jesus forth, wearing the crown of thorns, and the purple robe. And *Pilate* saith unto them, Behold the man!

6 When the chief priests therefore and officers saw him, they cried out, saying, Crucify *him*, crucify *him*. Pilate saith unto them, Take ye him, and crucify *him*: for I find no fault in him.

7 The Jews answered him, We have a law, and by our law he ought to die, because he made himself the Son of God.

8 When Pilate therefore heard that saying, he was the more afraid;

9 And went again into the judgment hall, and saith unto Jesus, Whence art thou? But Jesus gave him no answer.

10 Then saith Pilate unto him, Speakest thou not unto me? knowest thou not that I have power to crucify thee, and have power to release thee?

11 Jesus answered, Thou couldest have no power at all against me, except it were given thee from above: therefore he that delivered me unto thee hath the greater sin.

12 And from thenceforth Pilate sought to release him: but the Jews

cried out, saying, If thou let this man go, thou are not Caesar's friend: whosoever maketh himself a king speaketh against Caesar.

13 When Pilate therefore heard that saying, he brought Jesus forth, and sat down in the judgment seat in a place that is called the Pavement, but in the Hebrew, Gabbatha.

14 And it was the preparation of the passover, and about the sixth hour: and he saith unto the Jews, Behold your King!

15 But they cried out, Away with him, away with him, crucify him. Pilate saith unto them, Shall I crucify your King? The chief priests answered, We have no king but Caesar.

16 Then delivered he him therefore unto them to be crucified. And they took Jesus, and led *him* away.

17 And he bearing his cross went forth into a place called *the place* of a skull, which is called in the Hebrew Golgotha:

18 Where they crucified him, and two other with him, on either side one, and Jesus in the midst.

19 And Pilate wrote a title, and put *it* on the cross. And the writing was, JESUS OF NAZARETH THE KING OF THE JEWS.

20 This title then read many of the Jews: for the place where Jesus was crucified was nigh to the city: and it was written in Hebrew, *and* Greek, *and* Latin.

21 Then said the chief priests of the Jews to Pilate, Write not, The King of the Jews; but that he said, I am King of the Jews.

22 Pilate answered, What I have written I have written.

23 Then the soldiers, when they

had crucified Jesus, took his garments, and made four parts, to every soldier a part; and also *his* coat: now the coat was without seam, woven from the top throughout.

24 They said therefore among themselves, Let us not rend it, but cast lots for it, whose it shall be: that the scripture might be fulfilled, which saith, They parted my raiment among them, and for my vesture they did cast lots. These things therefore the soldiers did.

25 Now there stood by the cross of Jesus his mother, and his mother's sister, Mary the *wife* of Cleophas, and Mary Magdalene.

26 When Jesus therefore saw his mother, and the disciple standing by, whom he loved, he saith unto his mother, Woman, behold thy son!

27 Then saith he to the disciple, Behold thy mother! And from that hour that disciple took her unto his own *home*.

28 After this, Jesus knowing that all things were now accomplished, that the scripture might be fulfilled, saith, I thirst.

29 Now there was a set a vessel full of vinegar: and they filled a spunge with vinegar, and put *it* upon hyssop, and put *it* to his mouth.

30 When Jesus therefore had received the vinegar, he said, It is finished: and he bowed his head, and gave up the ghost.

Opposite: *The Crucifixion* oil on canvas Salvador Dali Spanish, 1904-

Left: Christ Crowned with Thorns engraving artist unknown American, c. 1890

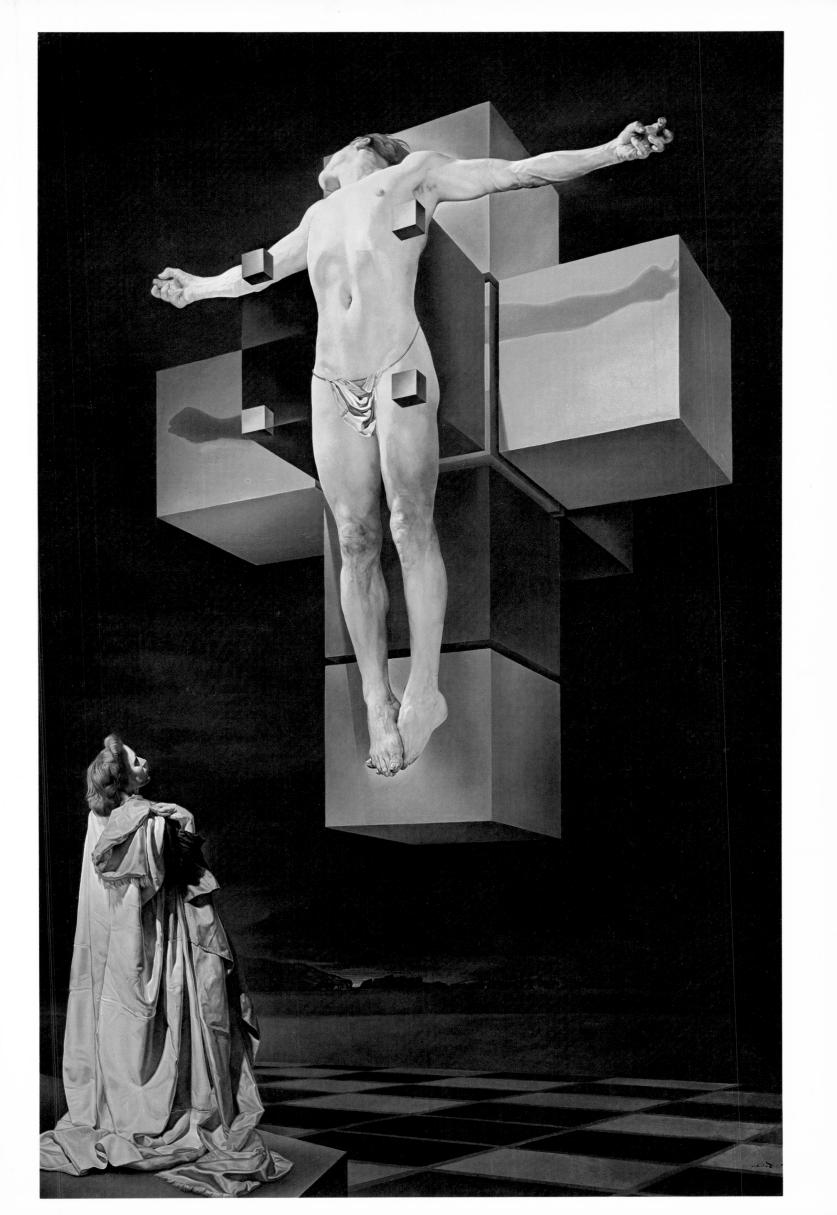

THE EPISTLE OF PAUL THE APOSTLE TO THE ROMANS 8:31-39

hat shall we then say to these things? If God *be* for us, who *can be* against us? 32 He that

spared not his own Son, but delivered him up for us all, how shall he not with him also freely give us all things?

33 Who shall lay any thing to the charge of God's elect? *It is* God that justifieth.

34 Who *is* he that condemneth? *It is* Christ that died, yea rather, that is risen again, who is even at the right hand of God, who also maketh intercession for us.

35 Who shall separate us from the love of Christ? *shall* tribulation, or distress, or persecution, or famine, or nakedness, or peril, or sword?

36 As it is written, For thy sake we are killed all the day long; we are accounted as sheep for the slaughter.

37 Nay, in all these things we are more than conquerors through him that loved us.

38 For I am persuaded, that neither death, nor life, nor angels, nor principalities, nor powers, nor things present, nor things to come,

39 Nor height, nor depth, nor any other creature, shall be able to separate us from the love of God, which is in Christ Jesus our Lord.

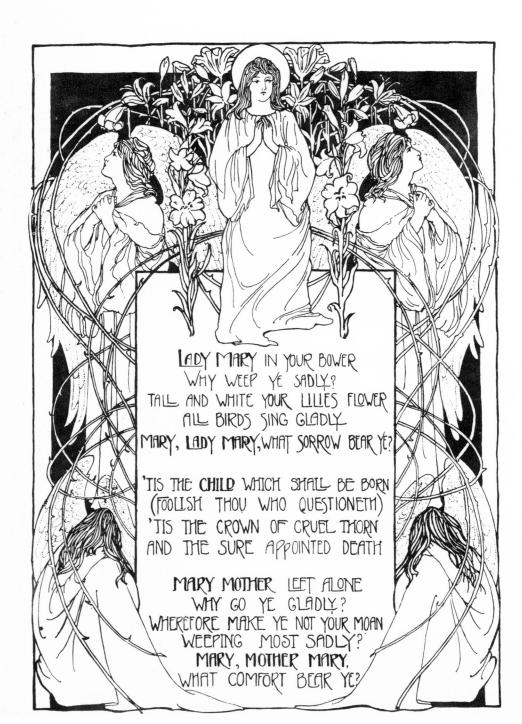

Opposite: *Pietà* marble sculpture Michelangelo Buonarroti Italian, 1475-1564

Left: Lady Mary in Your Bower illustration Claire Murrell English, c. 1900

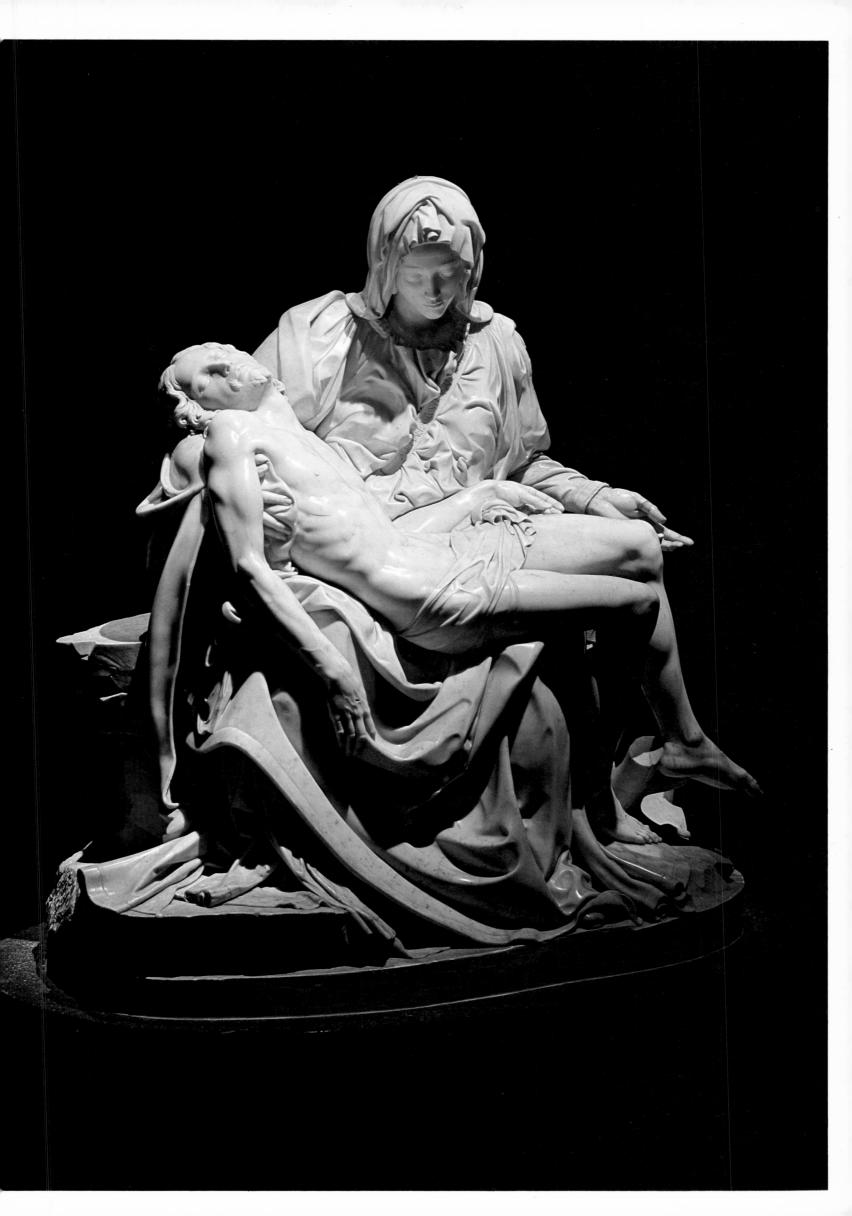

THE GOSPEL ACCORDING TO ST. MATTHEW 28

n the end of the sabbath, as it began to dawn toward the first *day* of the week, came Mary Magdalene and the other Mary to see the sepul-

2 And, behold, there was a great earthquake: for the angel of the Lord descended from heaven, and came and rolled back the stone from the door, and sat upon it.

3 His countenance was like lightning, and his raiment white as snow:

4 And for fear of him the keepers did shake, and became as dead *men*.

5 And the angel answered and said unto the women, Fear not ye: for I know that ye seek Jesus, which was crucified.

6 He is not here: for he is risen, as he said. Come, see the place where the Lord lay.

7 And go quickly, and tell his disciples that he is risen from the

dead; and, behold, he goeth before you into Galilee; there shall ye see him: lo, I have told you.

8 And they departed quickly from the sepulchre with fear and great joy; and did run to bring his disciples word.

9 And as they went to tell his disciples, behold, Jesus met them, saying, All hail. And they came and held him by the feet, and worshipped him.

10 Then said Jesus unto them, Be not afraid: go tell my brethren that they go into Galilee, and there shall they see me.

11 Now when they were going, behold, some of the watch came into the city, and shewed unto the chief priests all the things that were done.

12 And when they were assembled with the elders, and had taken counsel, they gave large money unto the soldiers,

13 Saying, Say ye, His disciples

came by night, and stole him away while we slept.

14 And if this come to the governor's ears, we will persuade him, and secure you.

15 So they took the money, and did as they were taught: and this saying is commonly reported among the Jews until this day.

16 Then the eleven disciples went away into Galilee, into a mountain where Jesus had appointed them.

17 And when they saw him, they worshipped him: but some doubted.

18 And Jesus came and spake unto them, saying, All power is given unto me in heaven and in earth.

19 Go ye therefore, and teach all nations, baptizing them in the name of the Father, and of the Son, and of the Holy Ghost:

20 Teaching them to observe all things whatsoever I have commanded you: and, lo, I am with you always, *even* unto the end of the world, Amen.

Resurrection portion of the Isenheim Altarpiece Matthias Grünewald German, c. 1475-1528

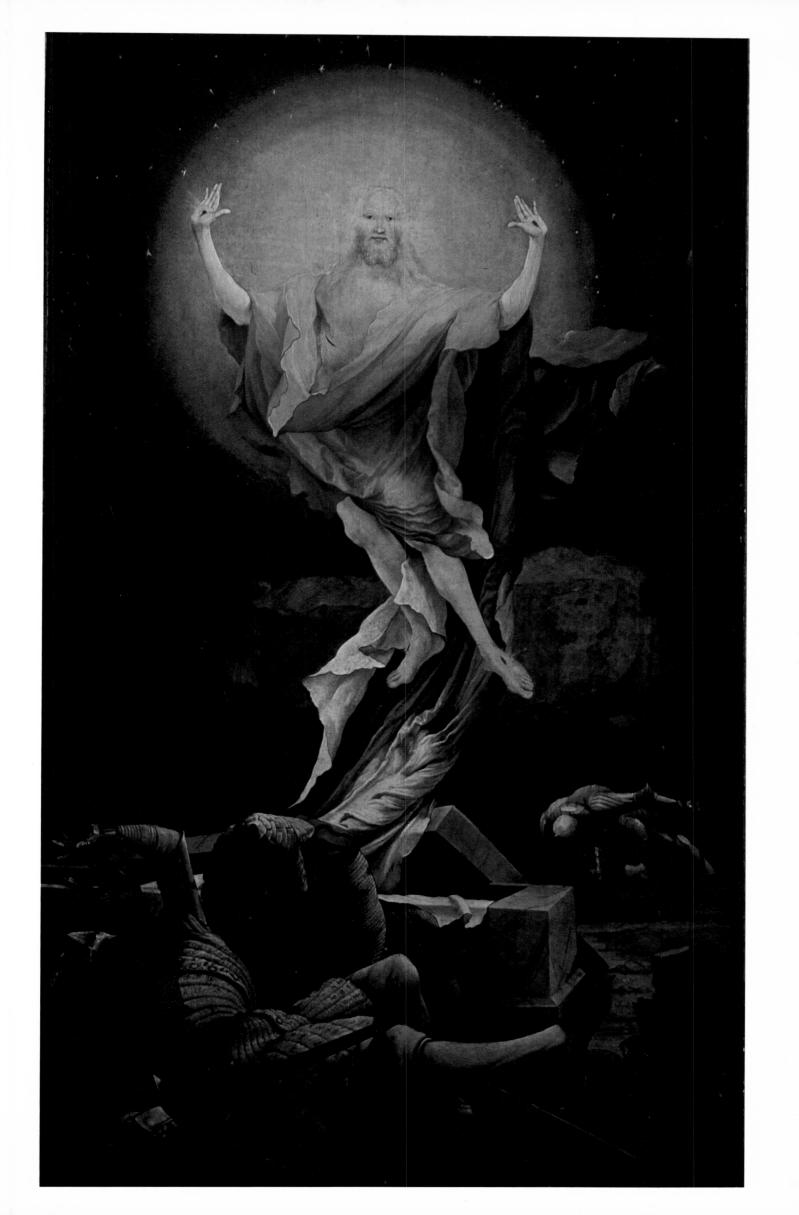

THE ACTS OF THE APOSTLES 2

nd when the day of Pentecost was fully come, they were all with one accord in one place. 2 And suddenly there came a sound from heaven as of a rushing might wind, and it

filled all the house where they were sitting.

3 And there appeared unto them cloven tongues like as of fire, and it sat upon each of them.

4 And they were all filled with the Holy Ghost, and began to speak with other tongues, as the Spirit gave them utterance.

5 And there were dwelling at Jerusalem Jews, devout men, out of every nation under heaven.

6 Now when this was noised abroad, the multitude came together, and were confounded, because that every man heard them speak in his own language.

7 And they were all amazed and marvelled, saying one to another, Behold, are not all these which speak Galilaeans?

8 And how hear we every man in our own tongue, wherein we were born?

9 Parthians, and Medes, and Elamites, and the dwellers in Mesopotamia, and in Judaea, and Cappadocia, in Pontus, and Asia,

10 Phrygia, and Pamphylia, in Egypt, and in the parts of Libya about Cyrene, and strangers of Rome, Jews and proselytes,

11 Cretes and Arabians, we do hear them speak in our tongues the wonderful works of God.

12 And they were all amazed, and were in doubt, saying one to another, What meaneth this?

13 Others mocking said, These men are full of new wine.

14 But Peter, standing up with the eleven, lifted up his voice, and said unto them, Ye men of Judaea, and all *ye* that dwell at Jerusalem, be this known unto you, and hearken to my words:

15 For these are not drunken, as ye suppose, seeing it is *but* the third hour of the day.

16 But this is that which was spoken by the prophet Joel;

17 And it shall come to pass in the last days, saith God, I will pour out of my Spirit upon all flesh: and your sons and your daughters shall prophesy, and your young men shall see visions, and your old men shall dream dreams:

18 And on my servants and on my handmaidens I will pour out in those days of my Spirit; and they shall prophesy:

19 And I will shew wonders in heaven above, and signs in the earth beneath; blood, and fire, and vapour of smoke:

20 The sun shall be turned into darkness, and the moon into blood, before that great and notable day of the Lord come:

21 And it shall come to pass, *that* whosoever shall call on the name of the Lord shall be saved.

22 Ye men of Israel, here these words; Jesus of Nazareth, a man approved of God among you by miracles and wonders and signs, which God did by him in the midst of you, as ye yourselves also know:

23 Him, being delivered by the determinate counsel and foreknowledge of God, ye have taken, and by wicked hands have crucified and slain:

24 Whom God hath raised up, having loosed the pains of death: because it was not possible that he should be holden of it.

25 For David speaketh concerning him, I foresaw the Lord always before my face, for he is on my right hand, that I should not be moved:

26 Therefore did my heart rejoice, and my tongue was glad; moreover also my flesh shall rest in hope:

27 Because thou wilt not leave my soul in hell, neither wilt thou suffer thine Holy One to see corruption.

28 Thou hast made known to me the ways of life; thou shalt make me full of joy with thy countenance.

29 Men *and* brethren, let me freely speak unto you of the patriarch David, that he is both dead and buried, and his sepulchre is with us unto this day.

30 Therefore being a prophet, and knowing that God had sworn with an oath to him, that of the fruit of his loins, according to the flesh, he would rise up Christ to sit on his throne;

31 He seeing this before spake of the resurrection of Christ, that his soul was not left in hell, neither his flesh did see corruption. 32 This Jesus hath God raised up, whereof we all are witnesses.

33 Therefore being by the right hand of God exalted, and having received of the Father the promise of the Holy Ghost, he hath shed forth this, which ye now see and hear.

34 For David is not ascended into the heavens: but he saith himself, The Lord said unto my Lord, Sit thou on my right hand,

35 Until I make thy foes thy footstool.

36 Therefore let all the house of Israel know assuredly, that God hath made that same Jesus, whom ye have crucified, both Lord and Christ.

37 Now when they heard *this*, they were pricked in their heart, and said unto Peter and to the rest of the apostles, Men *and* brethren, what shall we do?

38 Then Peter said unto them, Repent, and be baptized every one of you in the name of Jesus Christ for the remission of sins, and ye shall receive the gift of the Holy Ghost.

39 For the promise is unto you, and to your children, and to all that are afar off, *even* as many as the Lord our God shall call.

40 And with many other words did he testify and exhort, saying, Save yourselves from this untoward generation.

41 Then they that gladly received his word were baptized: and the same day there were added *unto them* about three thousand souls.

42 And they continued stedfastly in the apostles' doctrine and fellowship, and in breaking of bread, and in prayers.

43 And fear came upon every soul: and many wonders and signs were done by the apostles.

44 And all that believed were together, and had all things common;

45 And sold their possessions and goods, and parted them to all *men*, as every man had need.

46 And they, continuing daily with one accord in the temple, and breaking bread from house to house, did eat their meat with gladness and singleness of heart,

47 Praising God, and having favour with all the people. And the Lord added to the church daily such as should be saved.

Spanish, 1541-1614

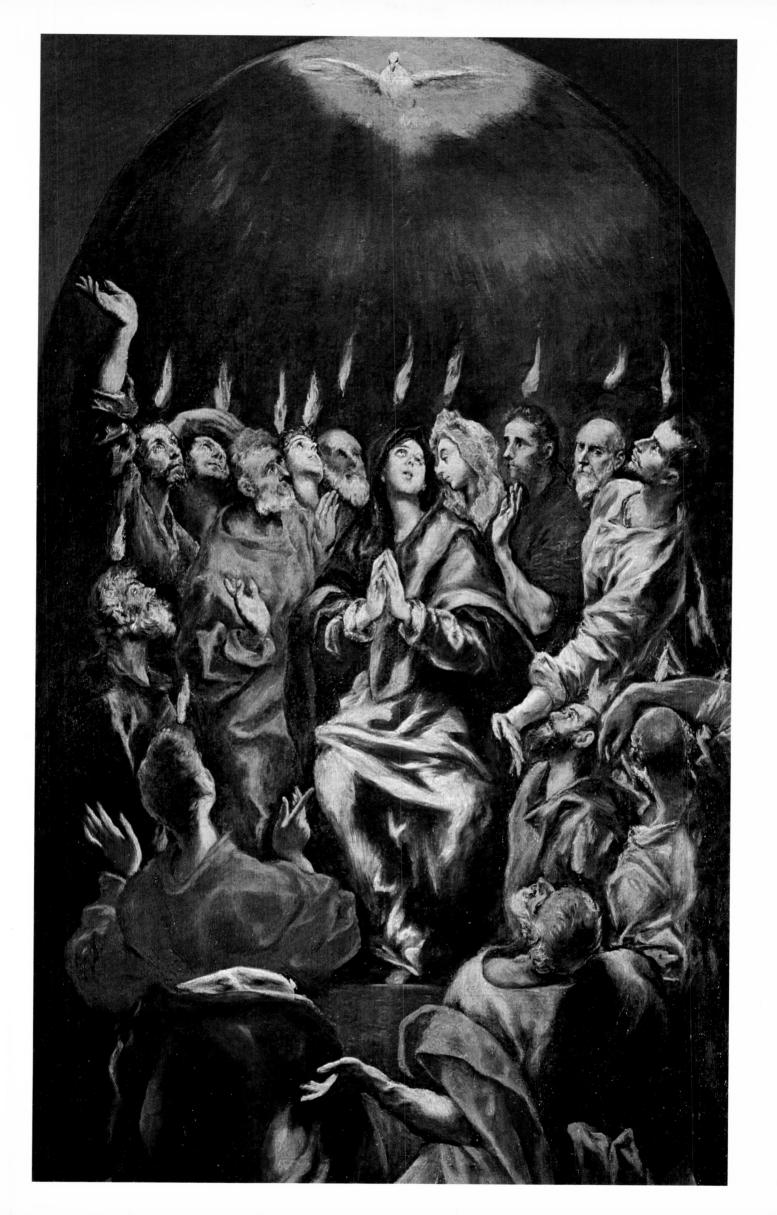

THE ACTS OF THE APOSTLES 9:1-22

nd Saul, yet breathing out threatenings and slaughter against the disciples of the Lord, went unto the high priest,

2 And desired of him letters to Damascus to the synagogues, that if he found any of this way, whether they were men or women, he might bring them bound unto Jerusalem.

3 And as he journeyed, he came near Damascus: and suddenly there shined round about him a light from heaven:

4 And he fell to the earth, and heard a voice saying unto him, Saul, Saul, why persecutest thou me?

5 And he said, Who art thou, Lord? And the Lord said, I am Jesus whom thou persecutest: *it is* hard for thee to kick against the pricks.

6 And he trembling and astonished said, Lord, what wilt thou have me to do? And the Lord *said* unto, Arise, and go into the city, and it shall be told thee what thou must do.

7 And the men which journeyed with him stood speechless, hearing a voice, but seeing no man.

8 And Saul arose from the earth; and when his eyes were opened, he saw no man: but they led him by the hand, and brought *him* into Damascus.

9 And he was three days without sight, and neither did eat nor drink.

10 And there was a certain disciple at Damascus, named Ananias; and to him said the Lord in a vision, Ananias. And he said, Behold, I *am here*, Lord.

11 And the Lord *said* unto him, Arise, and go into the street which is called Straight, and enquire in the house of Judas for *one* called Saul of Tarsus: for, behold, he prayeth.

12 And hath seen in a vision a man names Ananias coming in, and putting *his* hand on him, that he might receive his sight.

13 Then Ananias answered, Lord, I have heard by many of this man, how much evil he hath done to thy saints at Jerusalem:

14 And here he hath authority from the chief priests to bind all that call on thy name.

15 But the Lord said unto him, Go thy way: for he is a chosen vessel unto me, to bear my name before the Gentiles, and kings, and the children of Israel:

16 For I will shew him how great things he must suffer for my name's sake.

17 And Ananias went his way, and

entered into the house: and putting his hands on him said, Brother Saul, the Lord, even Jesus, that appeared unto thee in the way as thou camest, hath sent me, that thou mightest receive thy sight, and be filled with the Holy Ghost.

18 And immediately there fell from his eyes as it had been scales: and he received sight forthwith, and arose, and was baptized.

19 And when he had received meat, he was strengthened. Then was Saul certain days with the disciples which were at Damascus.

20 And straightway he preached Christ in the synagogues, that he is the Son of God.

21 But all that heard *him* were amazed, and said; Is not this he that destroyed them which called on this name in Jerusalem, and came hither for that intent, that he might bring them bound unto the chief priests?

22 But Saul increased the more in strength, and confounded the Jews which dwelt at Damascus, proving that this is very Christ.

The Conversion of St. Paul Oil on Canvas Michelangelo Merisi da Caravaggio Italian, 1573-1610

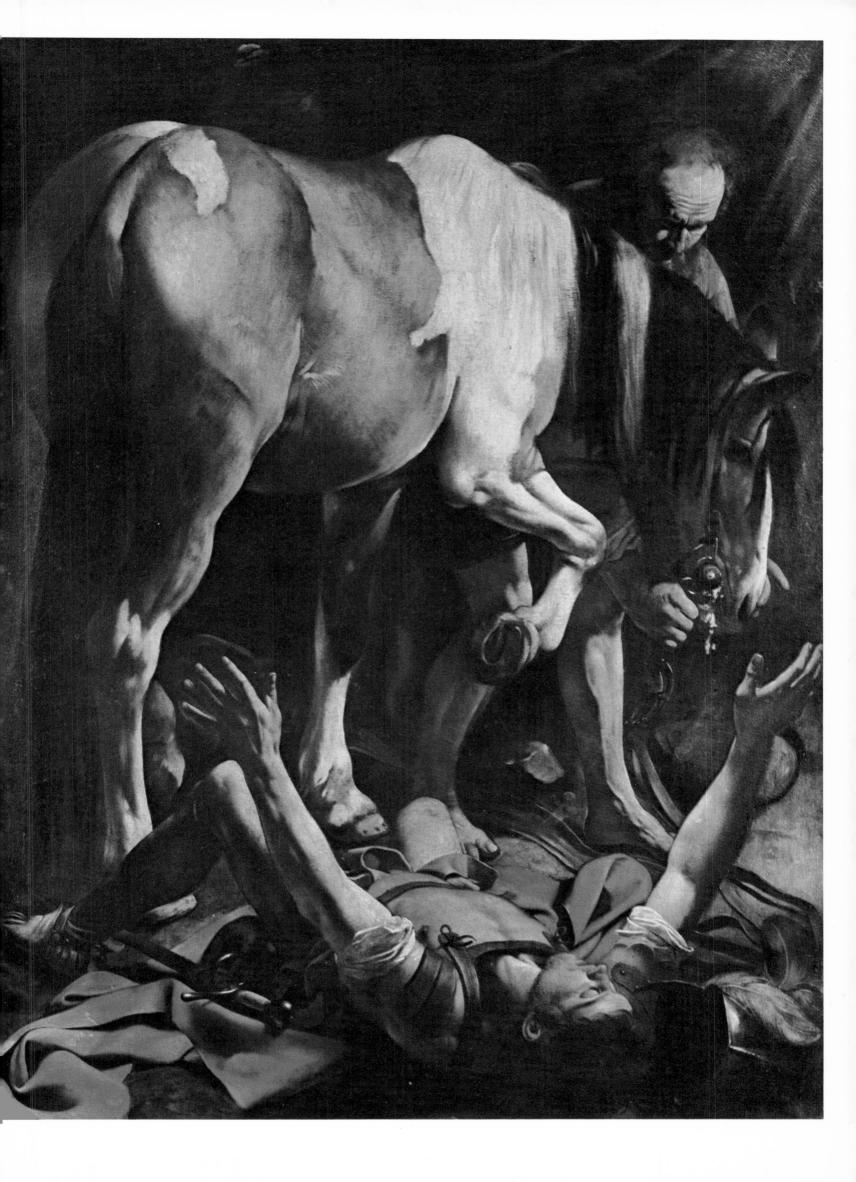

THE REVELATION OF ST. JOHN THE DIVINE 6

H

nd I saw when the Lamb opened one of the seals, and I heard, as it were the noise of thunder, one of the four beasts saying, Come and see.

2 And I saw, and behold a white horse: and he that sat on him had a bow; and a crown was given unto him: and he went forth conquering, and to conquer.

3 And when he had opened the second seal, I heard the second beast say, Come and see.

4 And there went out another horse *that was* red: and *power* was given to him that sat thereon to take peace from the earth, and that they should kill one another: and there was given unto him a great sword.

5 And when he had opened the third seal, I heard the third beast say, Come and see. And I beheld, and lo a black horse; and he that sat on him had a pair of balances in his hand.

6 And I heard a voice in the midst of the four beasts say, A measure of wheat for a penny, and three measures of barley for a penny; and *see* thou hurt not the oil and the wine.

7 And when he had opened the fourth seal, I heard the voice of the fourth beast say, Come and see.

8 And I looked, and behold a pale horse: and his name that sat on him was Death, and Hell followed with him. And power was given unto them over the fourth part of the earth, to kill with sword, and with hunger, and with death, and with the beasts of the earth.

9 And when he had opened the fifth seal, I saw under the altar the souls of them that were slain for the word of God, and for the testimony which they held:

10 And they cried with a loud voice, saying, How long, O Lord, holy and true, dost thou not judge and avenge our blood on them that dwell on the earth?

11 And white robes were given unto every one of them; and it was said unto them, that they should rest yet for a little season, until their fellowservants also and their brethren, that should be killed as they *were*, should be fulfilled.

12 And I beheld when he had opened the sixth seal, and, lo, there was a great earthquake; and the sun became black as sackcloth of hair, and the moon became as blood;

13 And the stars of heaven fell unto the earth, even as a fig tree casteth her untimely figs, when she is shaken of a mighty wind.

14 And the heaven departed as a scroll when it is rolled together; and every mountain and island were moved out of their places.

15 And the kings of the earth, and the great men, and the rich men, and the chief captains, and the mighty men, and every bondman, and every free man, hid themselves in the dens and in the rocks of the mountains;

16 And said to the mountains and rocks, Fall on us, and hide us from the face of him that sitteth on the throne, and from the wrath of the Lamb:

17 For the great day of his wrath is come; and who shall be able to stand?

The Riders on the Four Horses from the Apocalypse wood cut Albrecht Dürer German, 1471-1528

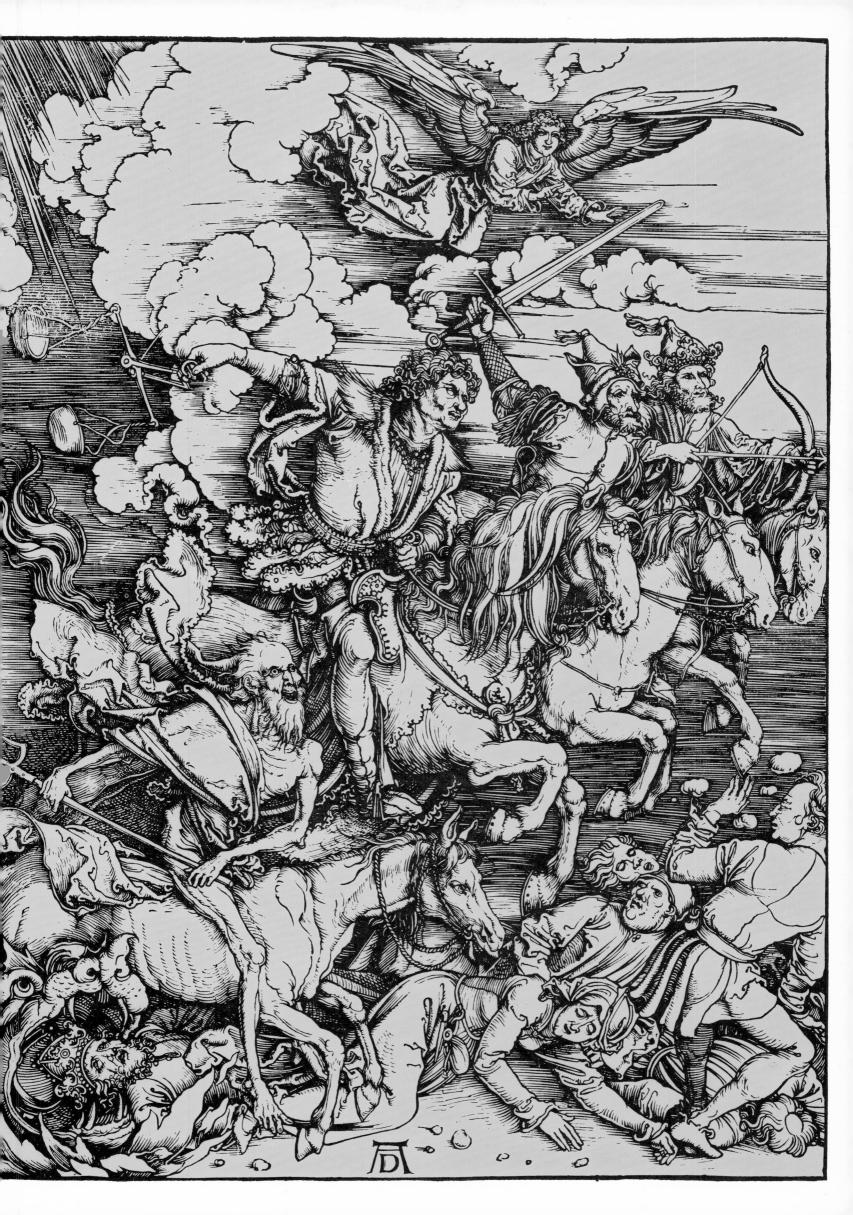

THE REVELATION OF ST. JOHN THE DIVINE 22

nd he shewed me a pure river of water of life, clear as crystal, proceeding out of the throne of God and of the Lamb. 2 In the midst of the

street of it, and on either side of the river, was there the tree of life, which bare twelve manner of fruits, and vielded her fruit every month: and the leaves of the tree were for the healing of the nations.

3 And there shall be no more curse: but the throne of God and of the Lamb shall be in it; and his servants shall serve him:

4 And they shall see his face; and his name shall be in their foreheads.

5 And there shall be no night there; and they need no candle, neither light of the sun; for the Lord God giveth them light: and they shall reign for ever and ever.

6 And he said unto me, These sayings are faithful and true: and the Lord God of the holy prophets sent his angel to shew unto his servants the things which must shortly be done.

7 Behold, I come quickly: blessed is he that keepeth the sayings of

the prophecy of this book.

8 And I John saw these things, and heard them. And when I had heard and seen, I fell down to worship before the feet of the angel which shewed me these things.

9 Then saith he unto me, See thou do it not: for I am thy fellowservant, and of thy brethren the prophets, and of them which keep the sayings of this book: worship God.

10 And he saith unto me, Seal not the sayings of the prophecy of this book: for the time is at hand.

11 He that is unjust, let him be unjust still: and he which is filthy, let him be filthy still: and he that is righteous, let him be righteous still: and he that is holy, let him be holy still.

12 And, behold, I come quickly; and my reward is with me, to give every man according as his work shall be.

13 I am Alpha and Omega, the beginning and the end, the first and the last.

14 Blessed are they that do his commandments, that they may have right to the tree of life, and may enter it through the gates into the city.

15 For without are dogs, and sor-

cerers, and whoremongers, and murderers, and idolaters, and whosoever loveth and maketh a lie.

16 I Jesus have sent mine angel to testify unto you these things in the churches. I am the root and the offspring of David, and the bright and morning star.

17 And the Spirit and the bride say, Come. And let him that heareth say, Come. And let him that is athirst come. And whosoever will, let him take the water of life freely.

18 For I testify unto every man that heareth the words of the prophecy of this book, If any man shall add unto these things, God shall add unto him the plagues that are written in this book:

19 And if any man shall take away from the words of the book of this prophecy, God shall take away his part out of the book of life, and out of the holy city, and from the things which are written in this book.

20 He which testifieth these things saith, Surely I come quickly. Amen. Even so, come, Lord Jesus.

21 The grace of our Lord Jesus Christ be with you all. Amen.

THE LEAVES OF THE TREE

Opposite: The Last Judgment detail tempera and oil on canvas, transferred from wood Jan van Evck Dutch, 1422-1441 Left: "And the leaves of the tree were for the healing of the nations." etching artist unknown American, nineteenth century

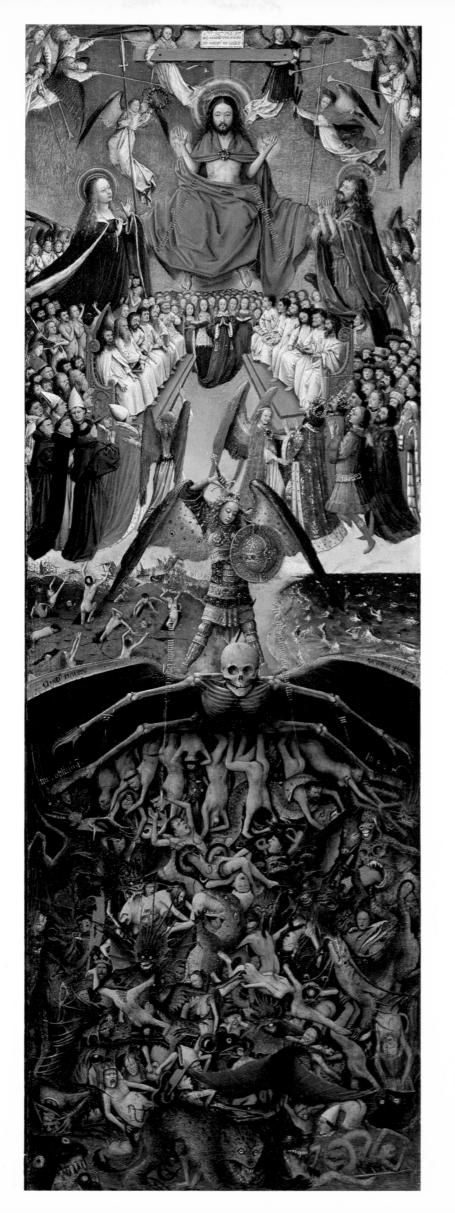

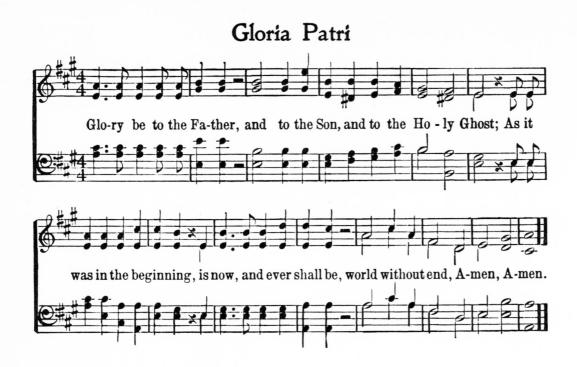

Opposite: Sunday in the Country oil on canvas E. Melvin Bolstad American, nineteenth century

Left: Gloria in Excelcis engraving American, c. 1890

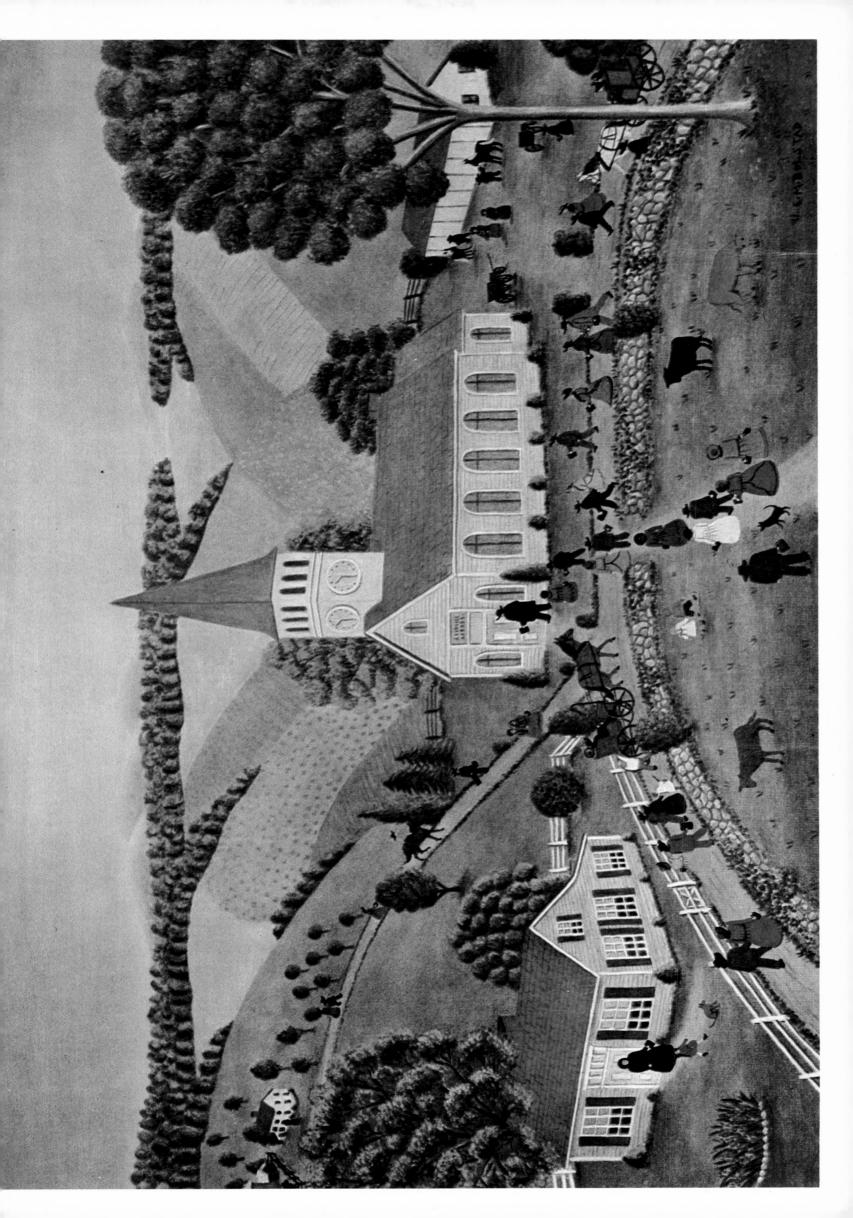

ACKNOWLEDGMENTS

- Whitworth Art Gallery, University of Man-5 chester, England.
- 6 Collection of the New York Public Library.
- 7 Photograph by the Vatican Museums.
- The Metropolitan Museum of Art, New York, 9 The Robert Lehman Collection, 1973.
- Philadelphia Museum of Art, bequest of 11 Lisa Norris Elkins.
- Kunsthistorisches Museum, Vienna. 13
- The St. Mark's Library of the General 15 Theological Seminary, New York.
- Bibliothèque Nationale, Paris, 19
- The Archbishop of Canterbury and the 21 Trustees of the Lambeth Palace Library, London.
- The Royal Museum of Fine Arts, Copen-23 hagen.
- 25 The National Gallery of Art, Washington, D.C., The Samuel H. Kress Collection.
- The Metropolitan Museum of Art, New York. 27
- Rijksmuseum, Amsterdam. 28
- Alte Pinakothek, Munich. 29

- The Metropolitan Museum of Art, New York, 31 Joseph Pulitzer Bequest, 1933, purchase.
- The Metropolitan Museum of Art, New York, 32 The Cloisters Collection, purchase.
- The Metropolitan Museum of Art, New York, 33 The Cloisters Collection, purchase.
- 35 The Metropolitan Museum of Art, New York, Fletcher Fund, 1933.
- Courtesy New York Graphic Society, Green-36 wich, Connecticut.
- Courtesy New York Graphic Society, Green-37 wich, Connecticut.
- The Metropolitan Museum of Art, New York. 38
- Cliché Musées Nationaux, Paris. 39
- Cliché Musées Nationaux, Paris. 41
 - The Metropolitan Museum of Art, New York, The Mr. and Mrs. Isaac D. Fletcher Col-
- 45 Albertina Museum, Vienna.
- The Metropolitan Museum of Art, New York. 48
- Courtesy New York Graphic Society, Green-49
- Metropolitan Museum of Art, New York, 50

- 51 Museo Civico di Padova, Padua.
- The Metropolitan Museum of Art, New York. 52 Courtesy New York Graphic Society, Green-53 wich. Connecticut.
- The Metropolitan Museum of Art, New York, 54 bequest of Julia H. Manges in memory of her
- husband, Dr. Morris Manges, 1960. 55 Courtesy New York Graphic Society, Greenwich. Connecticut.
- The Metropolitan Museum of Art, New York, 57 gift of The Chester Dale Collection, 1955.
- Dover Publications, Inc., New York, Art 58 Nouveau: An Anthology of Design and Illustration from The Studio, Edmund V.

Gillon, Jr.

59

63

- 43
 - lection, bequest of Isaac D. Fletcher, 1917.

- wich, Connecticut.
- The Cloisters Collection.
- Museo del Prado, Madrid. The Metropolitan Museum of Art, New York, 67 gift of Junius S. Morgan, 1919.

Photographs © Robert Hupka, New York.

- 69 The Metropolitan Museum of Art, New York, Fletcher Fund, 1933.
- Courtesy New York Graphic Society, Green-71 wich, Connecticut.